AUFWACKEN

JENS NOLTE

KERBER

IMPRES SUM / COLO PHON

KERBER PHOTO ART

Die Deutsche Nationalbibliothek verzeichnet diese Publikation in der Deutschen Nationalbibliografie; detaillierte bibliografische Daten sind im Internet über http://www.dnb.de abrufbar.
The Deutsche Nationalbibliothek lists this publication in the Deutsche Nationalbibliografie; detailed bibliographic data are available on the Internet at http://www.dnb.de.

Gesamtherstellung und Vertrieb / Printed and published by:
Kerber Verlag, Bielefeld
Windelsbleicher Str. 166–170
33659 Bielefeld
Germany
Tel. +49 (0) 5 21/9 50 08-10
Fax +49 (0) 5 21/9 50 08-88
info@kerberverlag.com

Kerber, US Distribution
D.A.P., Distributed Art Publishers, Inc.
155 Sixth Avenue, 2nd Floor
New York, NY 10013
Tel. +1 (212) 627-1999
Fax +1 (212) 627-9484

Kerber-Publikationen werden weltweit in führenden Buchhandlungen und Museumsshops angeboten (Vertrieb in Europa, Asien, Nord- und Südamerika). / Kerber publications are available in selected bookstores and museum shops worldwide (distributed in Europe, Asia, South and North America).

ISBN 978-3-7356-0250-3
www.kerberverlag.com

Printed in Germany

Herausgeber / Editor:
Jens Nolte

Gestaltung / Design:
Kerstin Bunke

Projektmanagement / Project Management, Kerber Verlag:
Katrin Meder

Lektorat / Copyediting:
Vera Nolte

Übersetzungen / Translations:
Jens Nolte

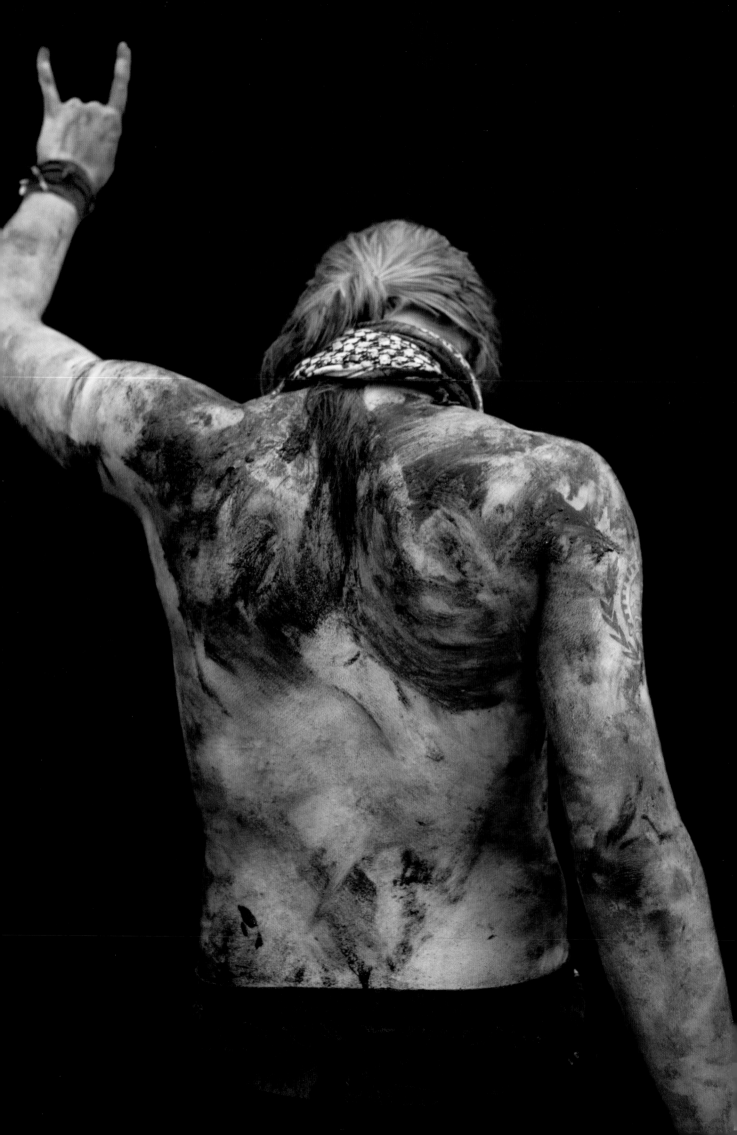

ANKÜNDI
GUNG

STANDBILDER EINES TRAUMS

Wie fotografiert man ein Musik-Event, das jedes Jahr aufs Neue binnen Stunden ausverkauft ist, ohne dass auch nur ein Fan weiß, wer eigentlich spielt. Die Pilgerstätte ist Droge, Gottesdienst, das größte Metal-Festival der Welt – und gleichzeitig das familiärste, persönlichste.

Eigentlich fotografiert man so etwas gar nicht, sondern feiert mit. Lässt sich reinziehen, treiben. Vergisst die Grenzen zwischen Tag und Nacht, Wachen und Schlafen. Alles verschwimmt. Alles fließt. Ein Kokon aus Musik, Party, Freundschaft, Alkohol, Leidenschaft, Liebe, Ekstase, Erschöpfung, Vergessen …

Oder man macht es so wie Jens Nolte. Man feiert viele Jahre mit, taucht ein, unter und nur mühsam wieder auf. Und wenn die Sonne schon wieder am Himmel steht, legt man die Kamera neben die Iso-Matte im Zelt, schläft wenige Stunden, träumt – und fotografiert die Bilder dieser Träume.

Hat Jens Nolte so seine Bilder gemacht? Mit Sicherheit, sonst wären sie nicht so, wie sie sind: gestochen-unscharf, real-surreal, verträumt-dokumentarisch – andere Bilder von einem anderen Festival. Wacker goes REM-Phase – Aufwachen strengstens verboten!

Peter Scharf Journalist & Filmemacher

ANNOUNCE MENT

AUFWACKEN – FREEZING THE DREAM

How do you capture a Music-Event, which is sold out within hours, without anyone even knowing which Band will play the Lead. The place of pilgrimage is a drug, is divine service, the biggest Heavy Metal Festival in the world – and the most familiar and personal one.

Actually you don't take pictures of such moments. You let yourself go with the flow. You ride the tide. You won't be able to part day from night. Wake and sleep. Everything gets blurred. Everything flows. A cocoon of music, party, friendship, alcohol, passion, love, ecstasy, exhaustion, memory loss …

Or maybe you capture it like Jens Nolte probably did. You become an approved member, you party with the crowd for many years, you dive into the real Universe of Heavy Metal, drowning and hardly coming back out of it. And when the sun has risen up high in the sky, you put down your camera next to your sleepingbag, sleep a few hours and dream … and then take pictures of that dream.

Is this the way Jens Nolte came up with his pictures? Probably – as this is how they are: blurry focused, real-surreal, a strictly dreamlike documentary. Enigmatic Pictures from an enigmatic Festival. Wacken Open Air goes REM … Aufwacken strictly forbidden.

Peter Scharf, Journalist & Filmmaker

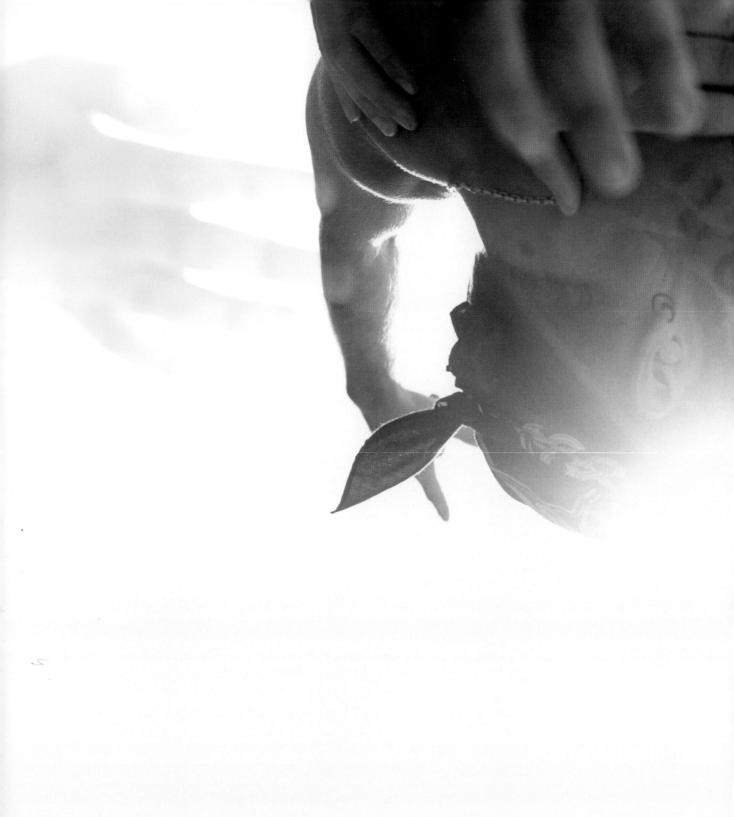

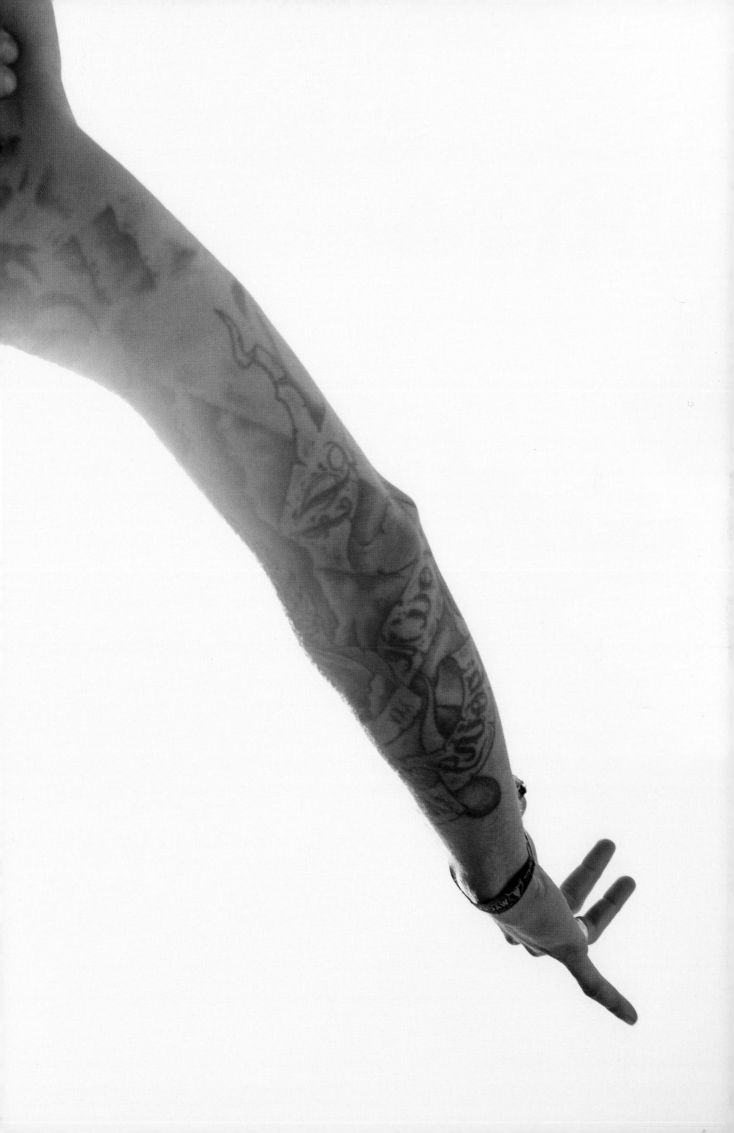

INTRO

Los, aufstehen! Rucksack? Gepackt! Zelt? Verstaut! Bier? Kalt! Links und rechts Autos. Leitplanken. Schilder. Eine Tankstelle. Zwei, drei, vier. Es regnet? Kann sein. Erst mal eine rauchen. Nur noch wenige Stunden. Heading north. Zu Hause verblasst. Ja, ich bin dann mal weg. Es wird grüner. Wiesen. Kühe. Vorsicht, Klischee! Ich habe Bock auf ein Bier. Auf eine Palette Bier. Elender Stau. Da steht's! Noch ein paar Kilometer. Mann, ist das voll hier. Jemand noch 'n Hering? Hält! Prost! Schulz, hahaha! Wer kommt mit? Die sind Mist. Die sind super. Ich finde die so mittel. Könnte lauter sein. Hast du das Mädel gesehen? Hast du den Typen gesehen? Riesenband! Noch 'n Bier? Lass mal ziehen. Es wird schon dunkel. In den Moshpit? Oh mein Gott. War DAS geil? Wie heißt du eigentlich? Schön, dass wir uns kennengelernt haben. Es wird schon wieder hell! Da müssen wir auch noch hin. Hey, das sind doch die von gestern! Prost! Klar, heute mal die andere Bühne. Super Wetter! Ich will hier nie wieder weg. Sie haben den Song tatsächlich gespielt! Sie haben den Song nicht gespielt! Lass uns ein paar Stunden schlafen. Ich kann nicht schlafen. Schon der letzte Tag? Nachher zockt noch meine Lieblingsband! Kommst du mit nach vorne? Zugabe, Zugabe! Ein Bier zum Abschluss? Ich bin todtraurig.

Boris Kaiser, RockHard Magazin

INTRO

C'mon, get up! Backpack? Ready! Tent? In the car! Beer? Cold! Cars everywhere. Crash barriers. Roadsigns. A gas station. Two, three, four. Rain? Possible. Let's have a smoke. Just a couple more hours in the car. Heading north. Home is fading. Yep, I'm off to Wacken. It's getting greener. Meadows. Cows. Watch out, sterotyping. I need a beer. A whole case of beer. Fucking traffic jam. There's the Townsign. Just a few kilometers. Boy, it is crowded. Tent up. Beer up. Prost! Who's ready to go in? They suck. They are awesome. I like them a little. Could be louder. Did you see that chick? Saw that Dude? Superband! One for the road? Let me have a drag of that. It's already getting dark. Moshpit? OMG. That's insane. What's your name? Nice to meet you. Sunrise, again! We definetely have to see that band. Hey, there are the Guys from yersterday! Prost! Sure, let's check the other stage today. Great weather! I never want to leave this place. They really played that song! They did not play that song! Please, some hours of sleep. I can't sleep. What, it's the last day, already? My favourite Band is playing later. Join me in the first row? Zugabe, Zugabe! Final beer? I am devastated.

Boris Kaiser, RockHard Magazine

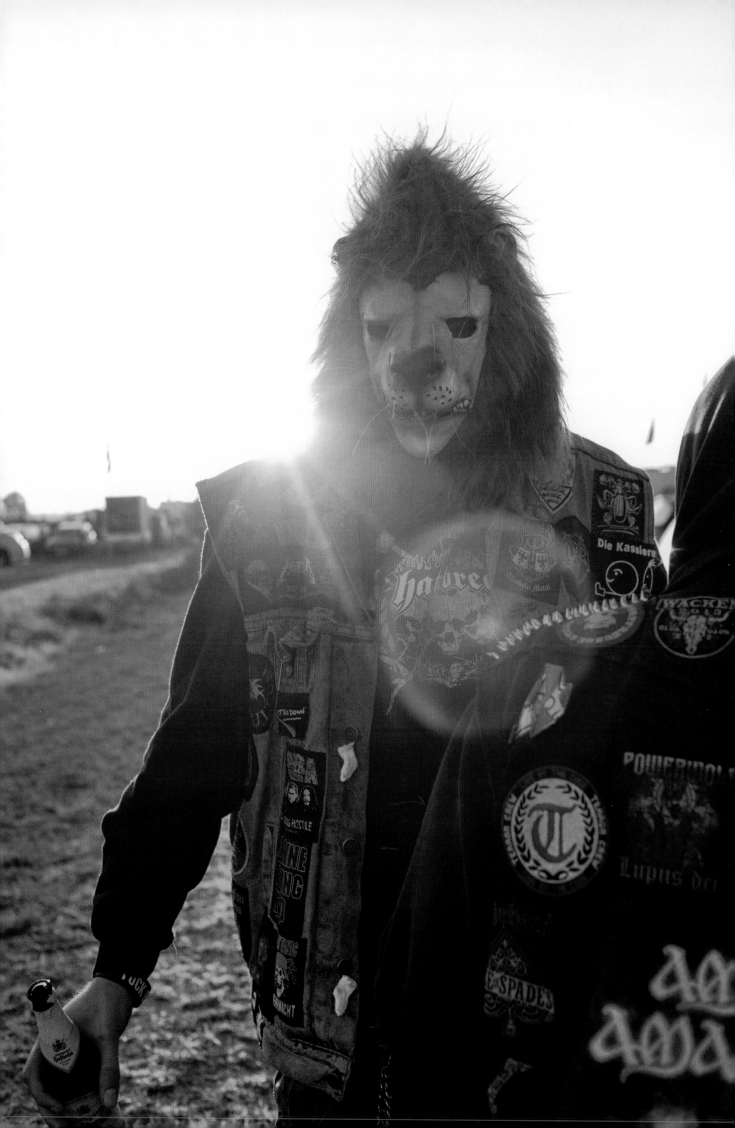

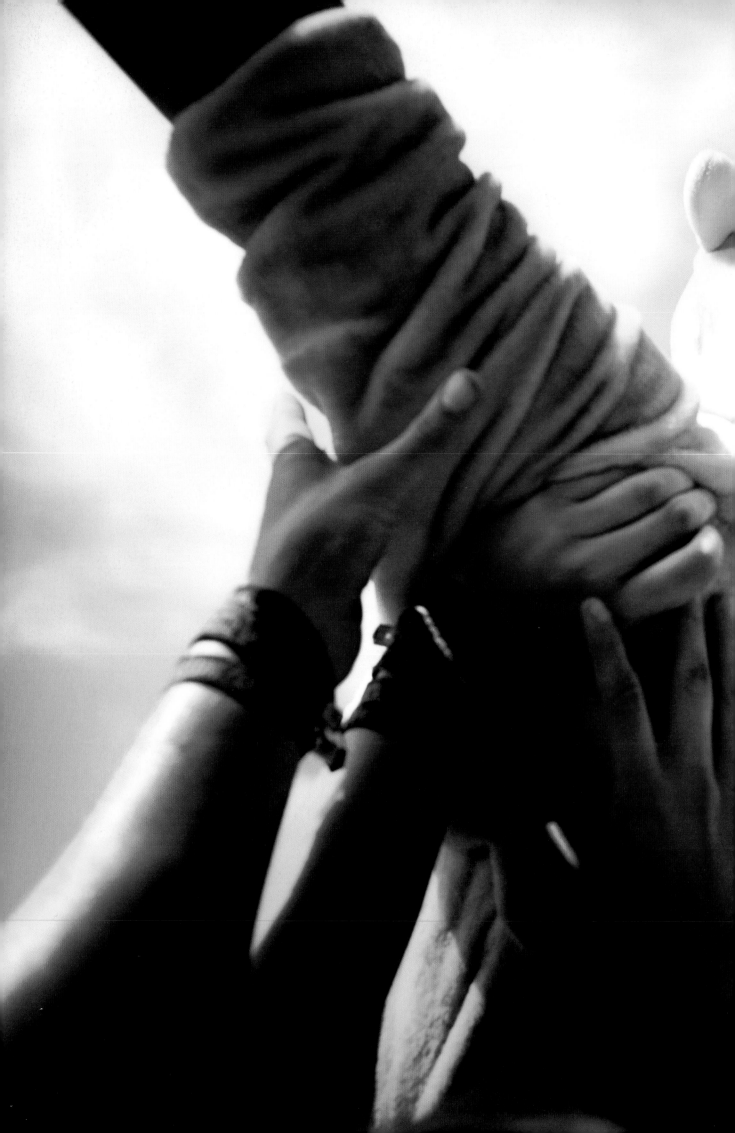

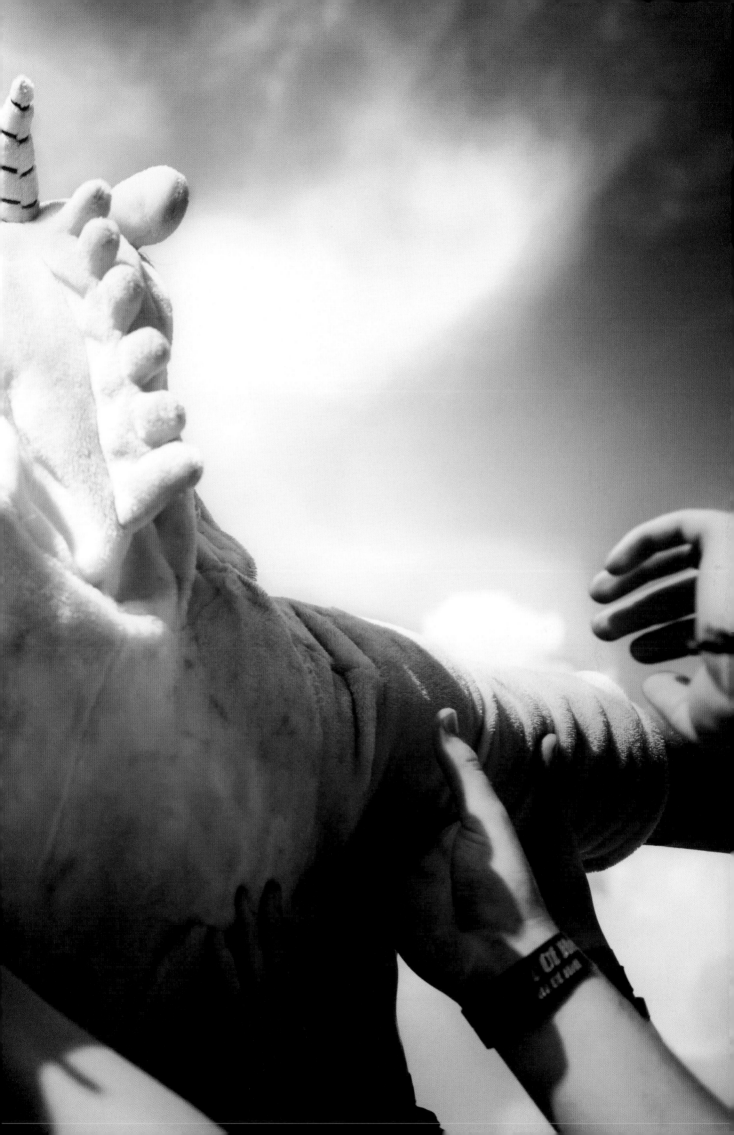

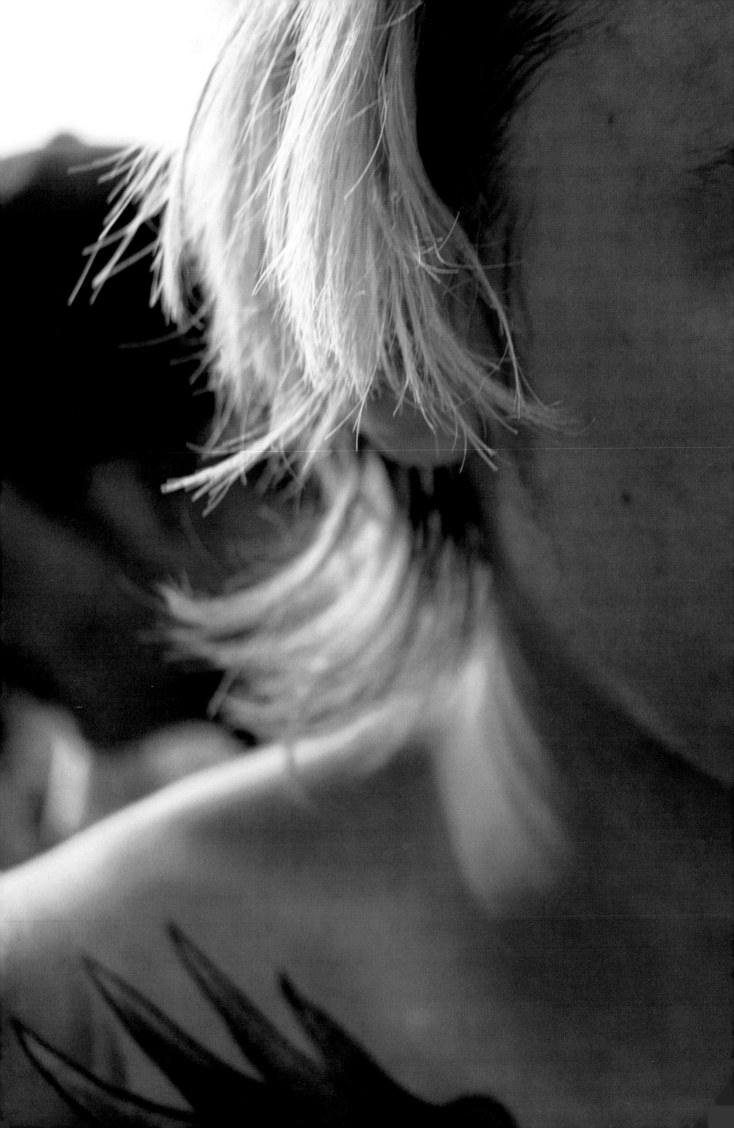

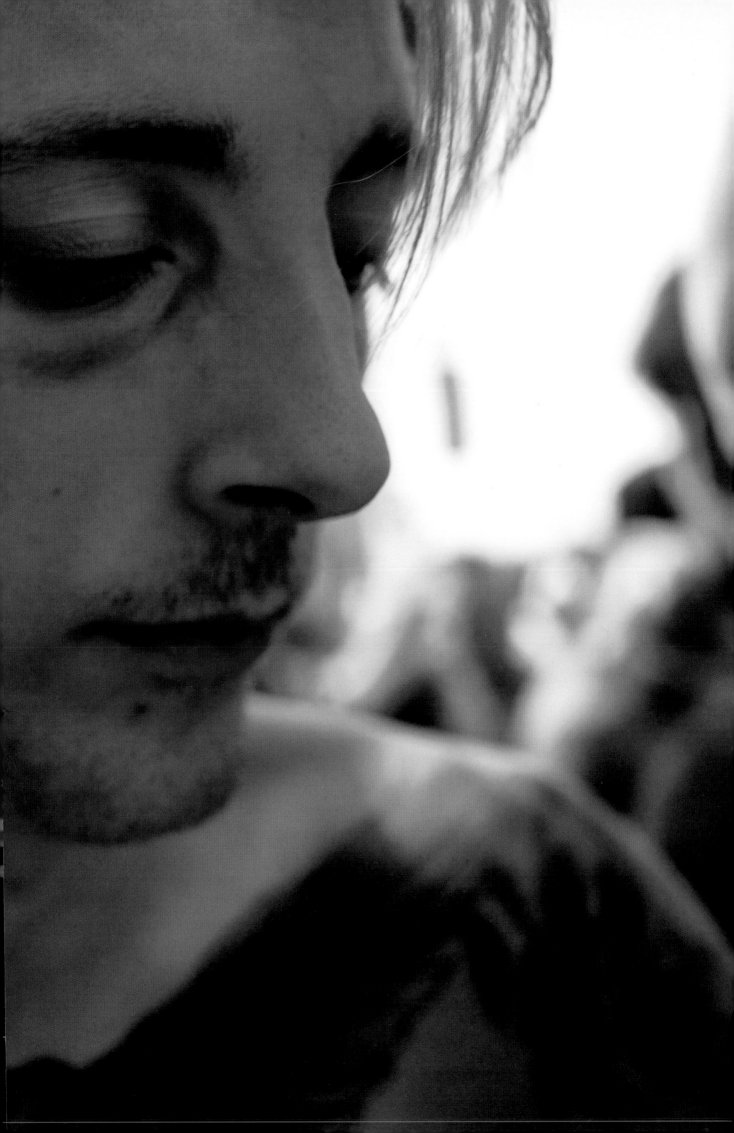

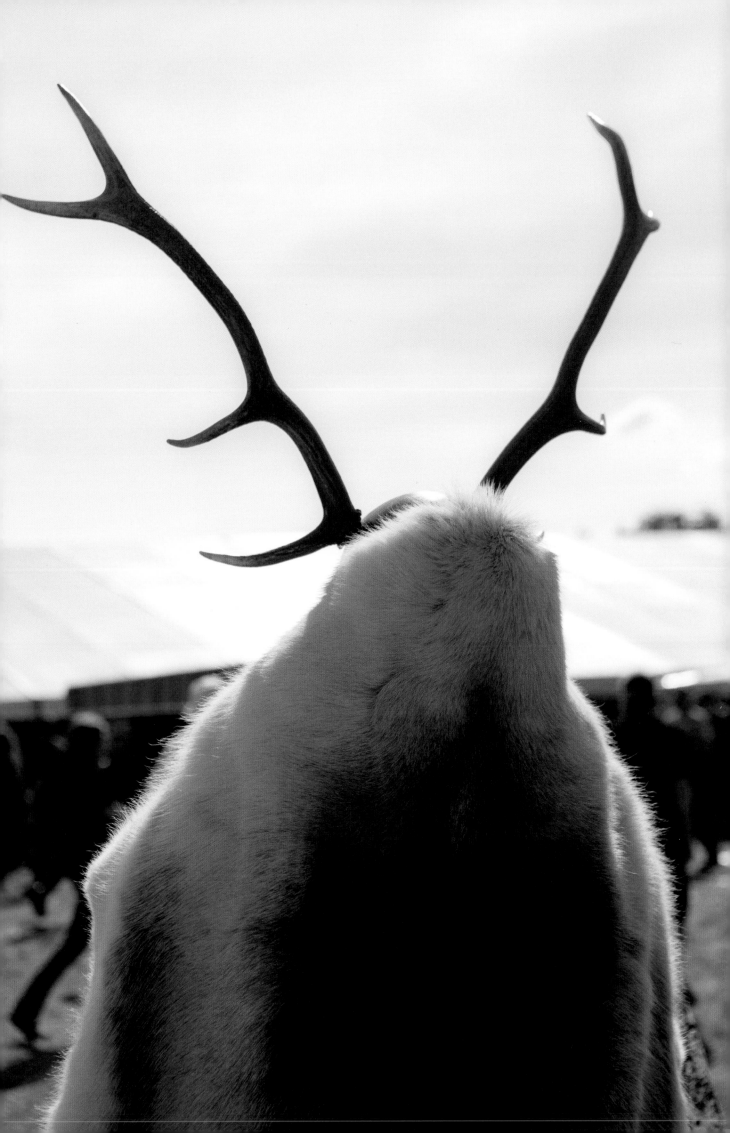

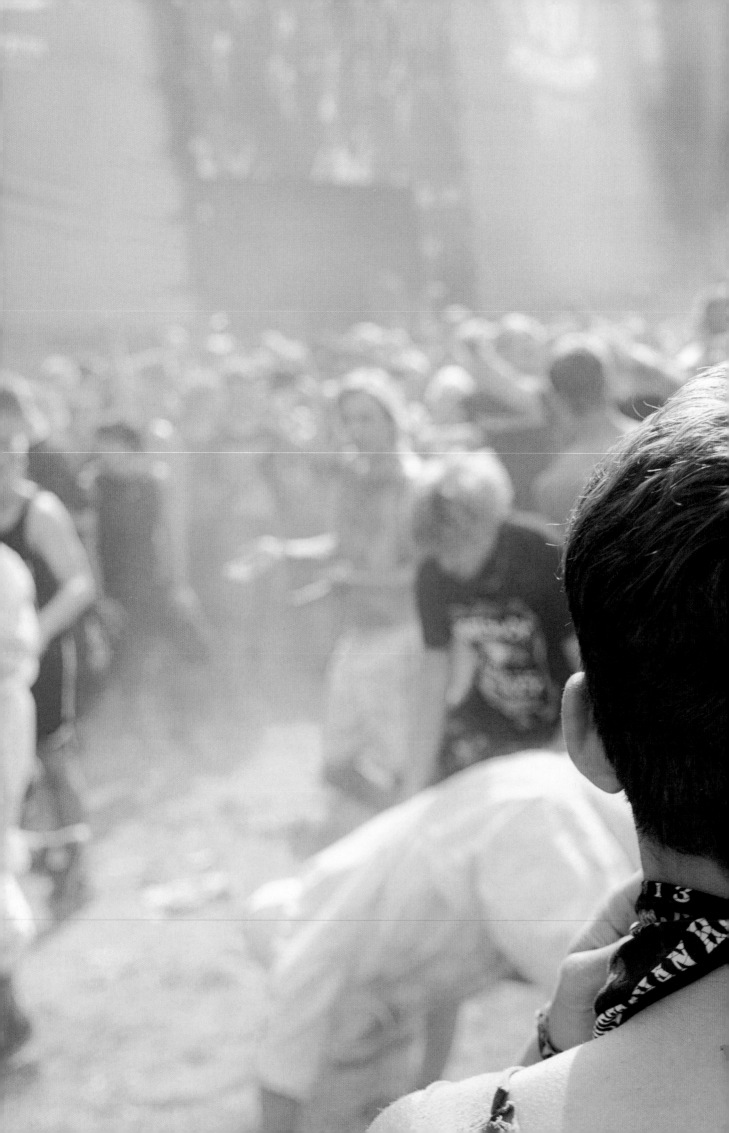

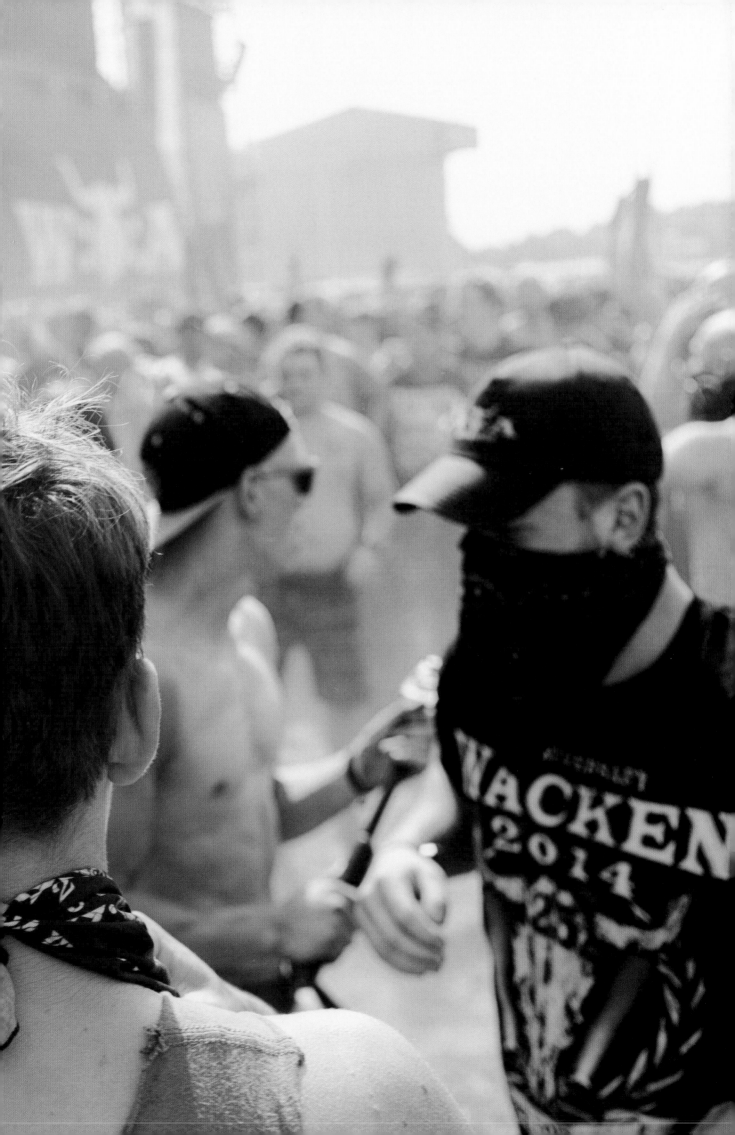

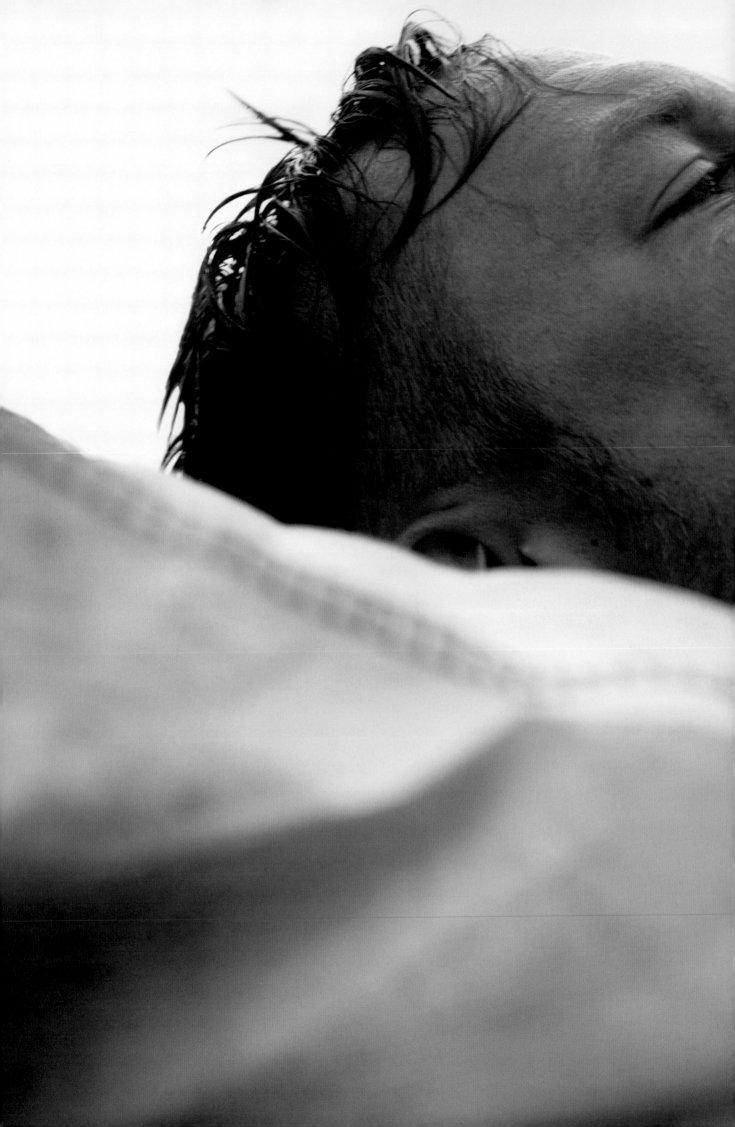

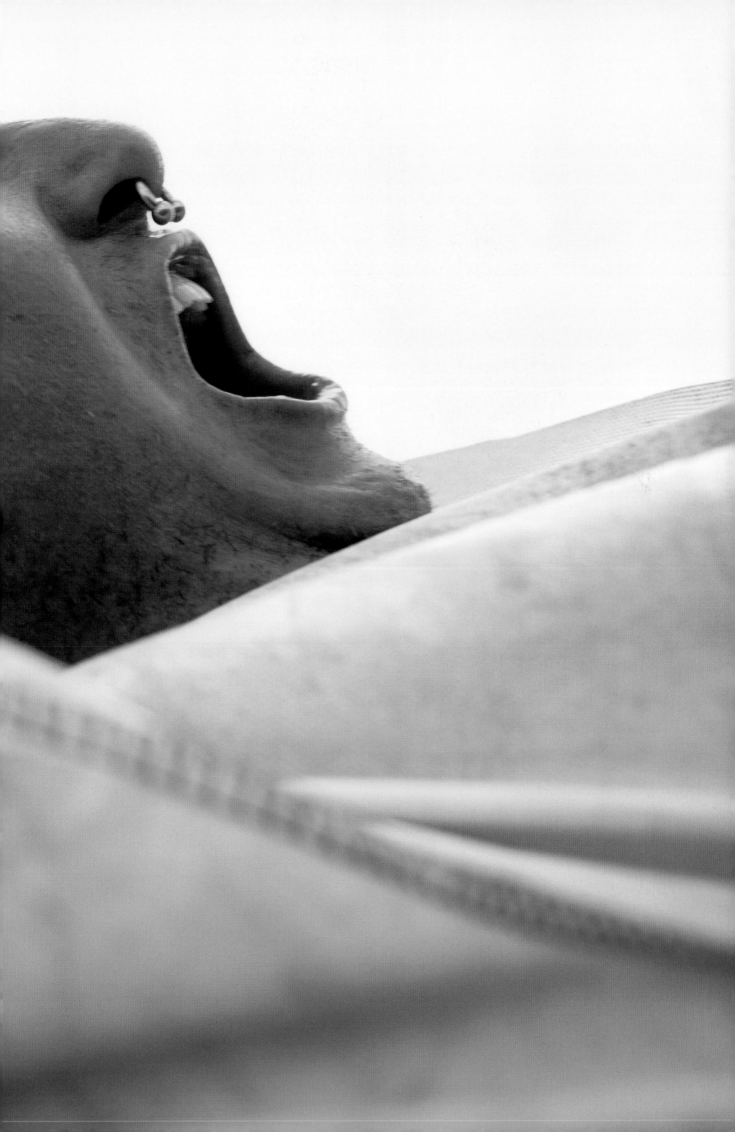

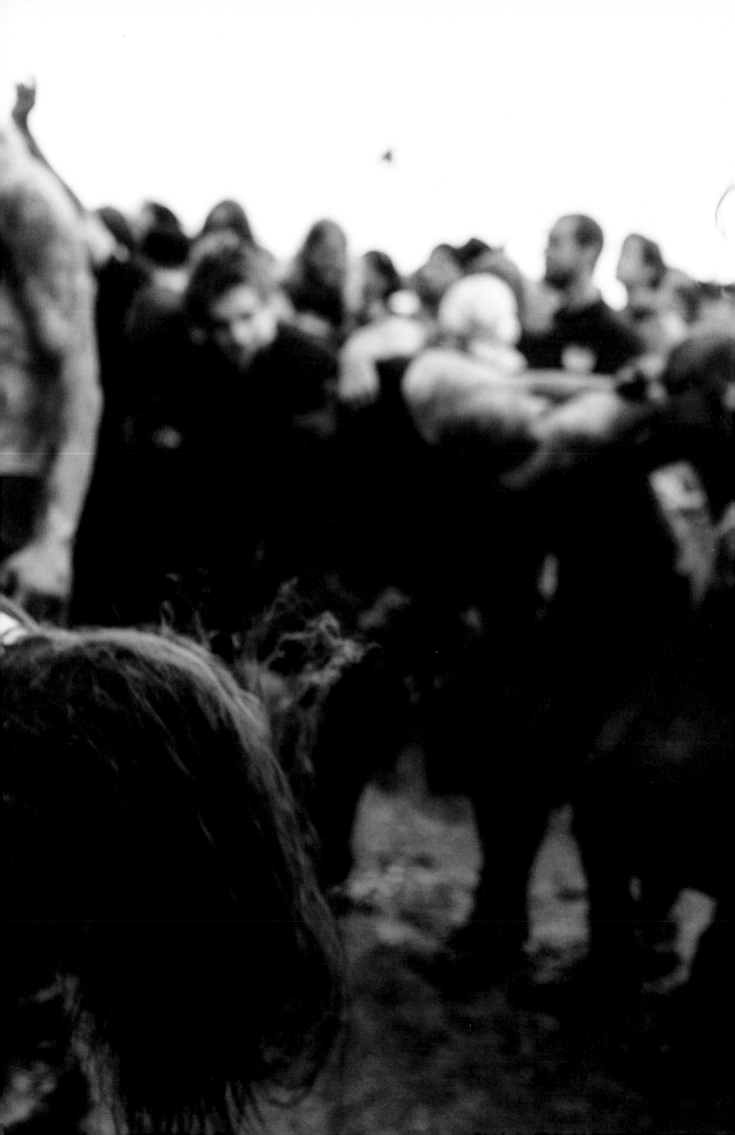

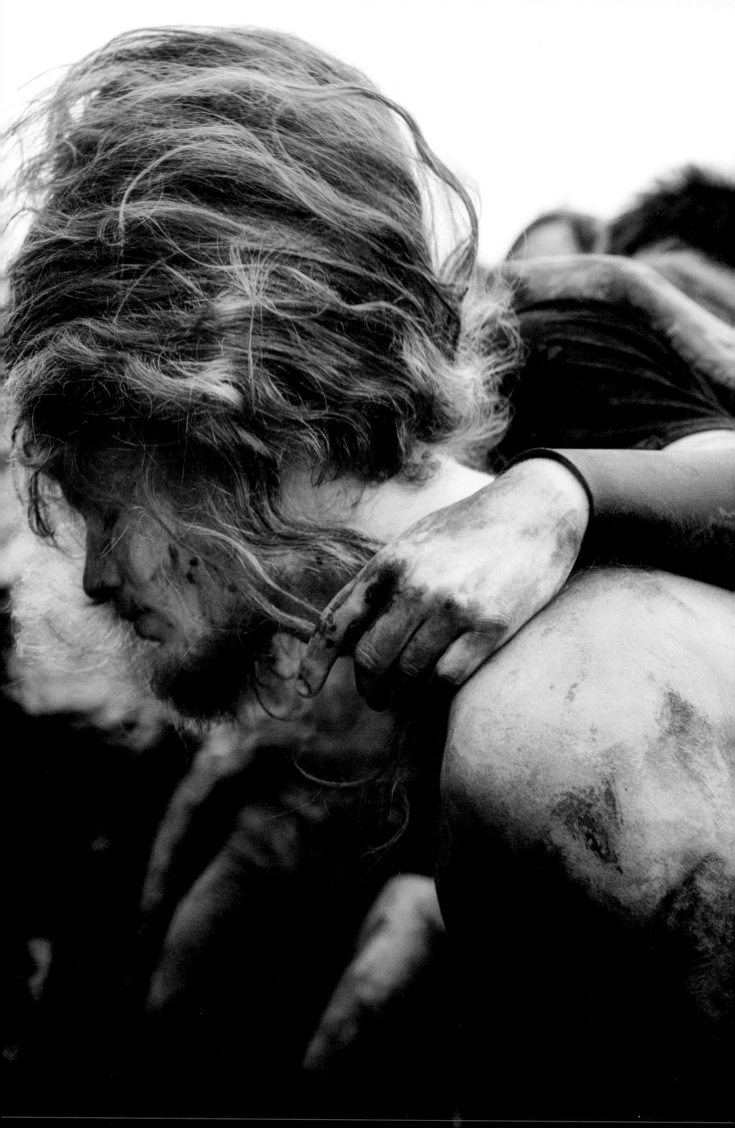

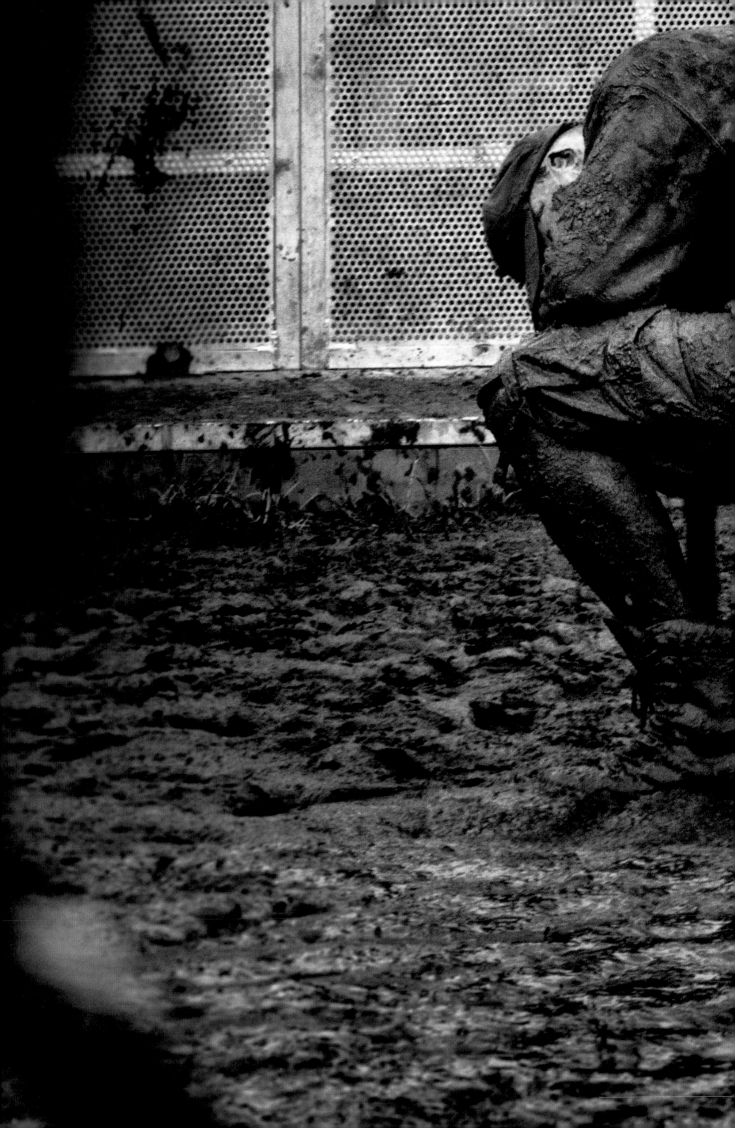

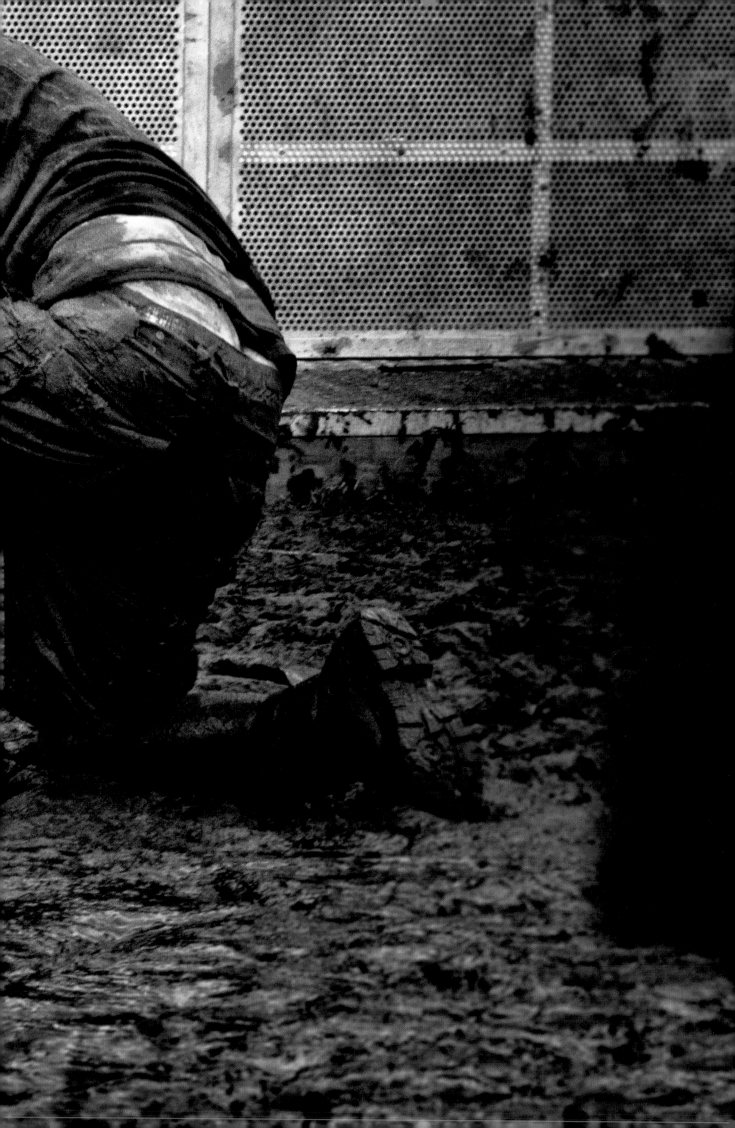

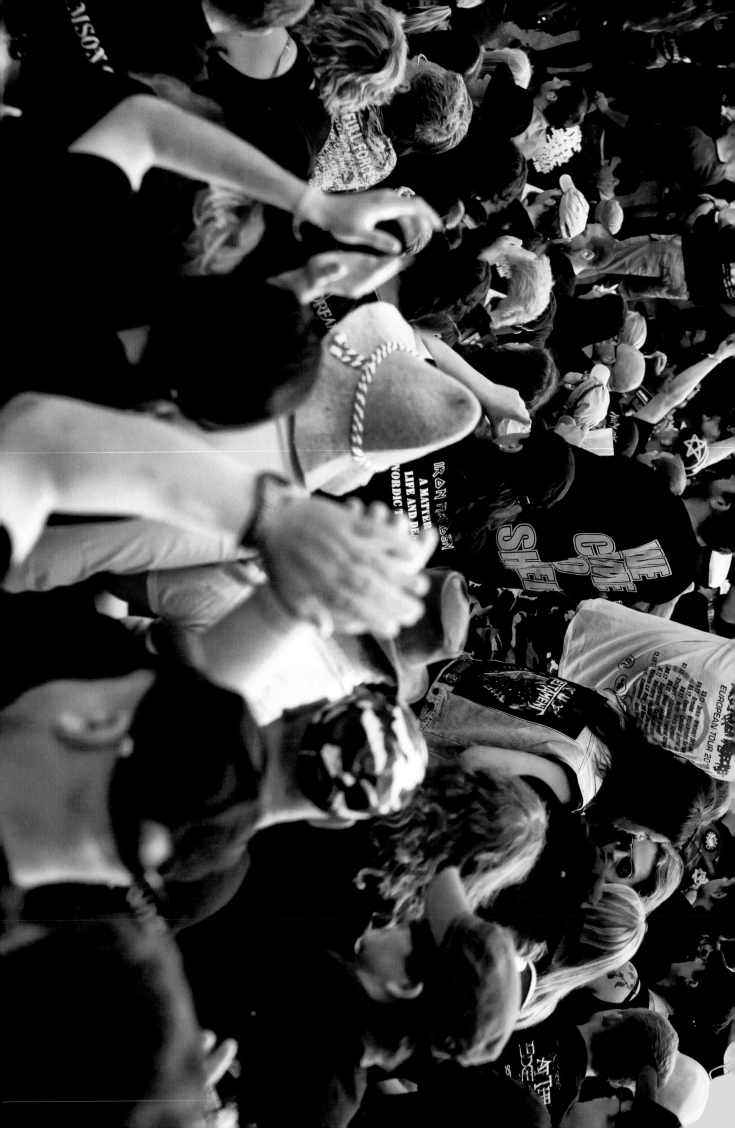

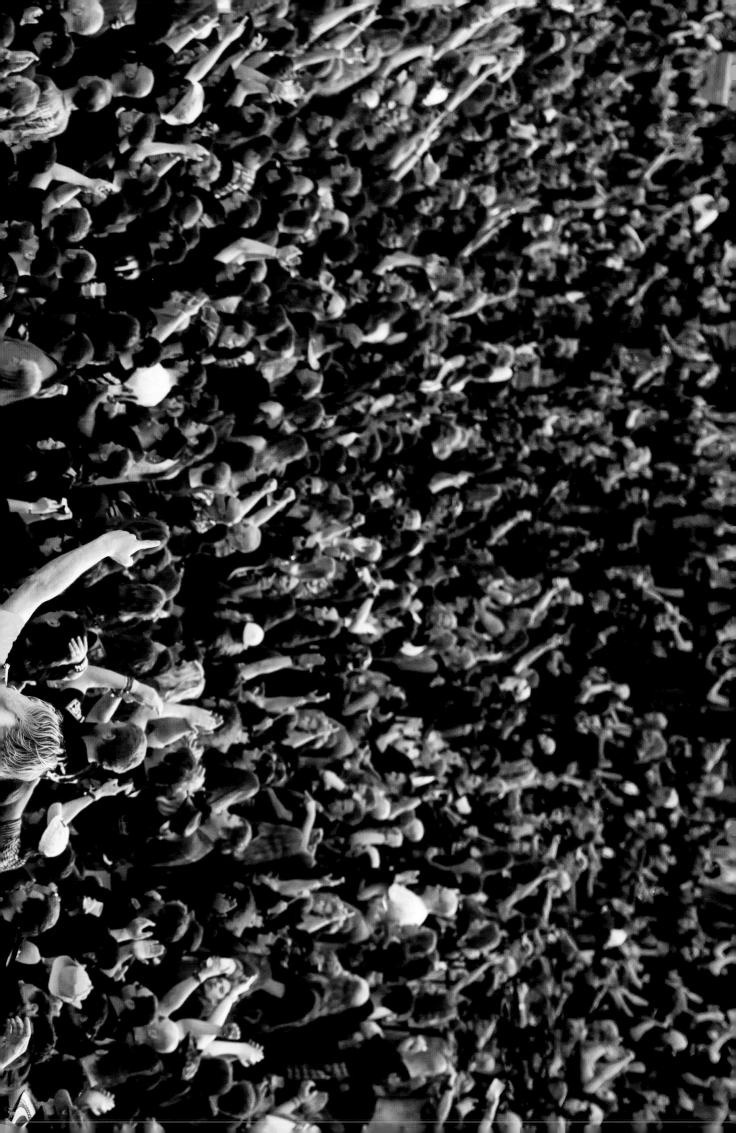

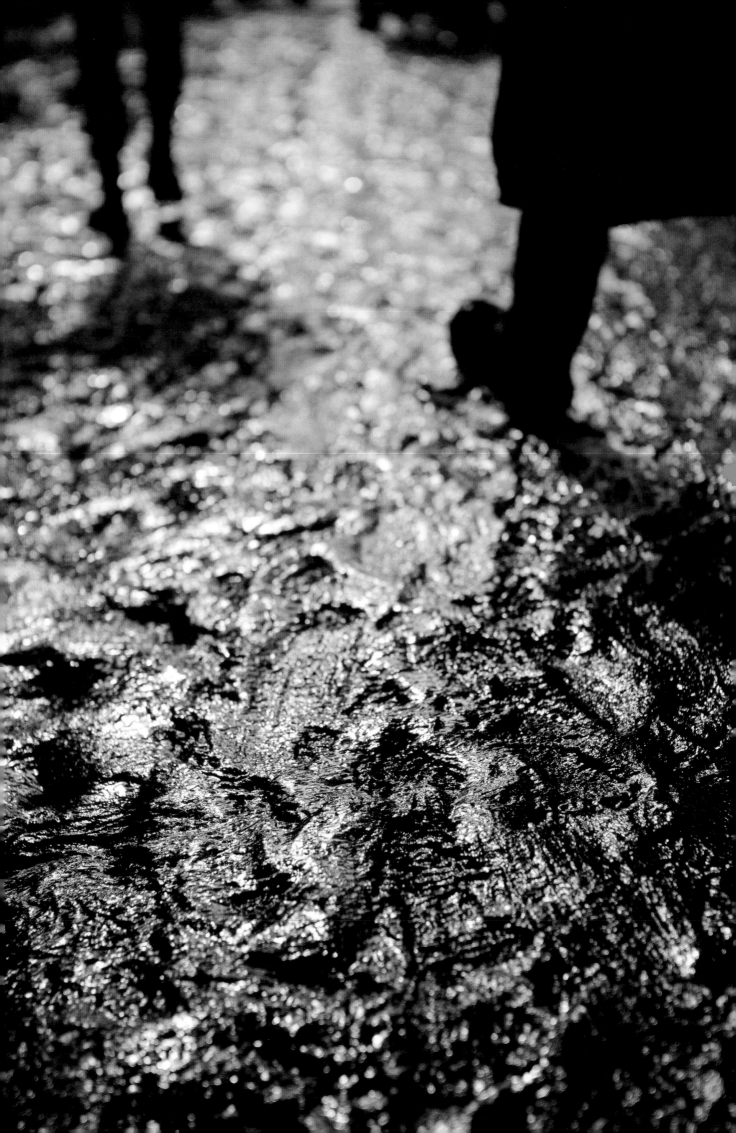

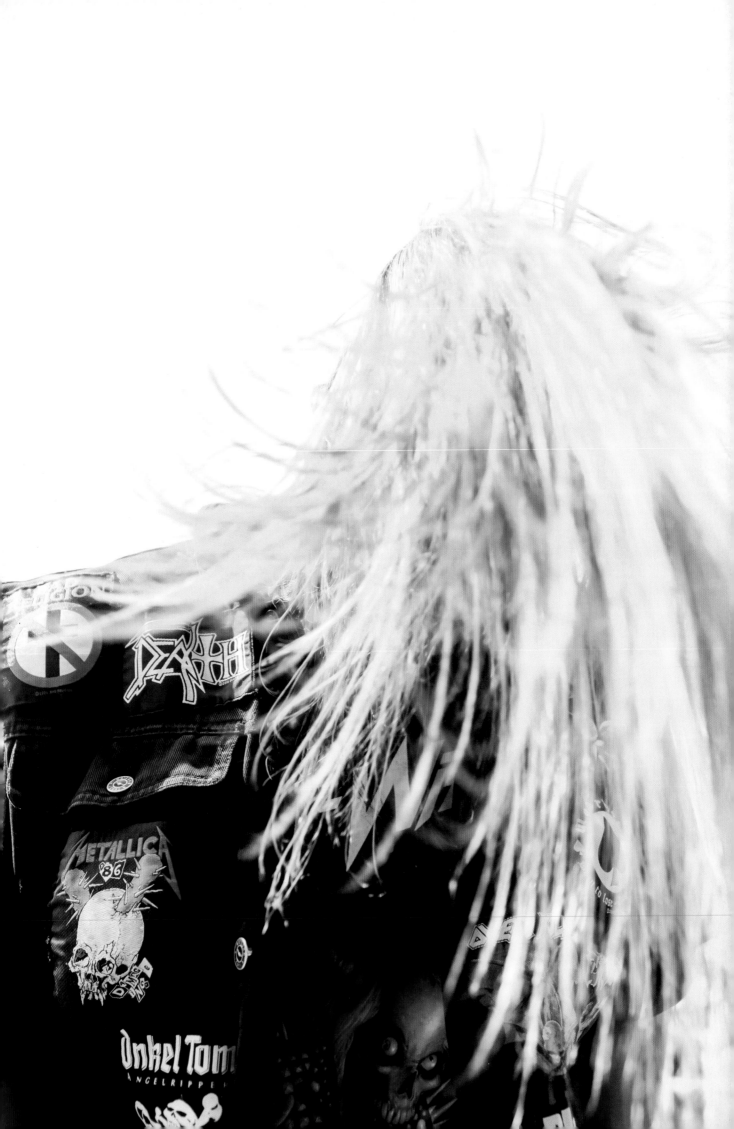

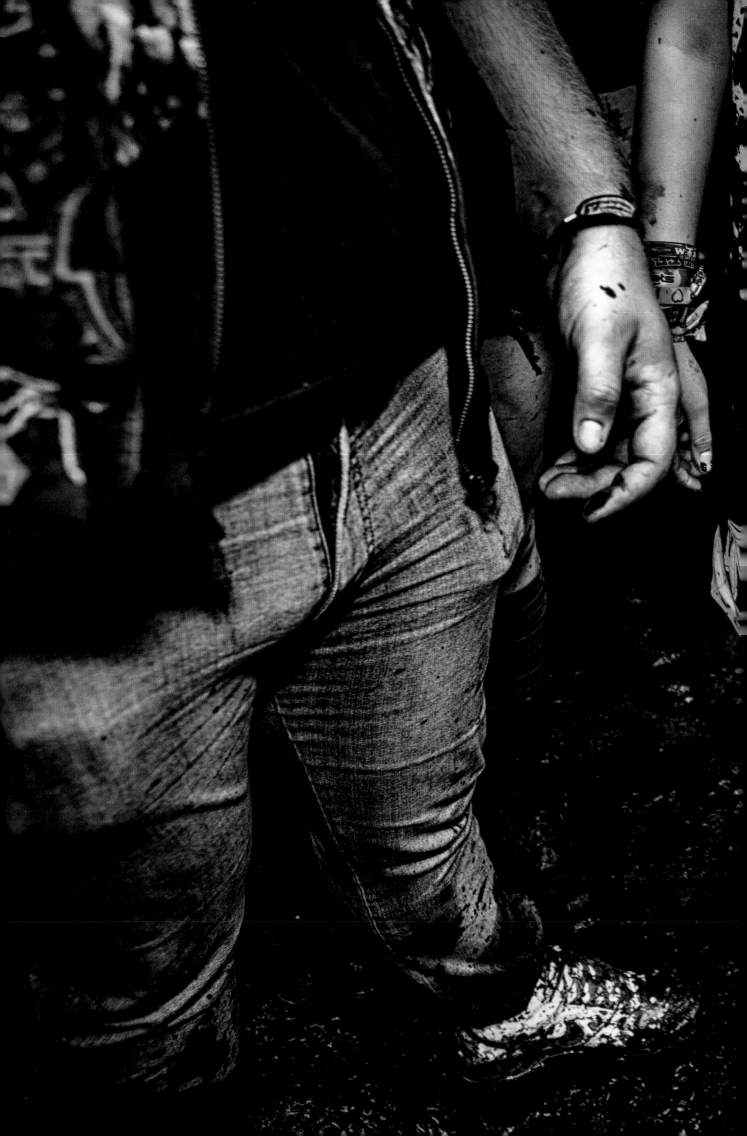

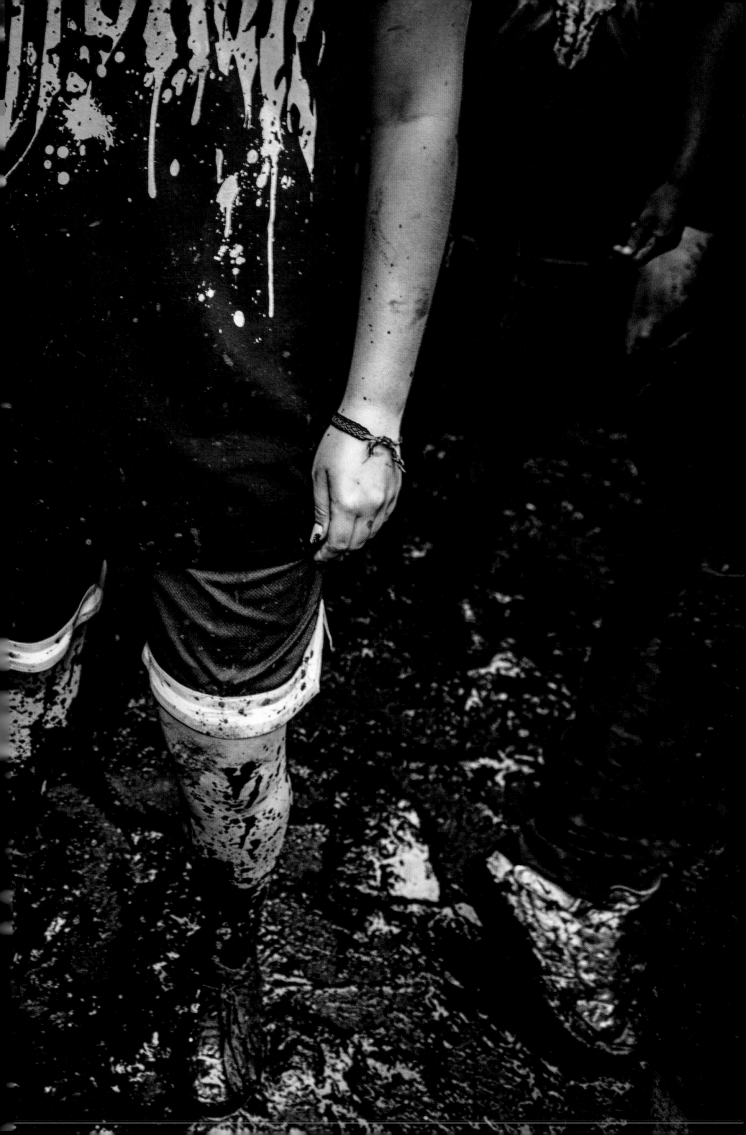

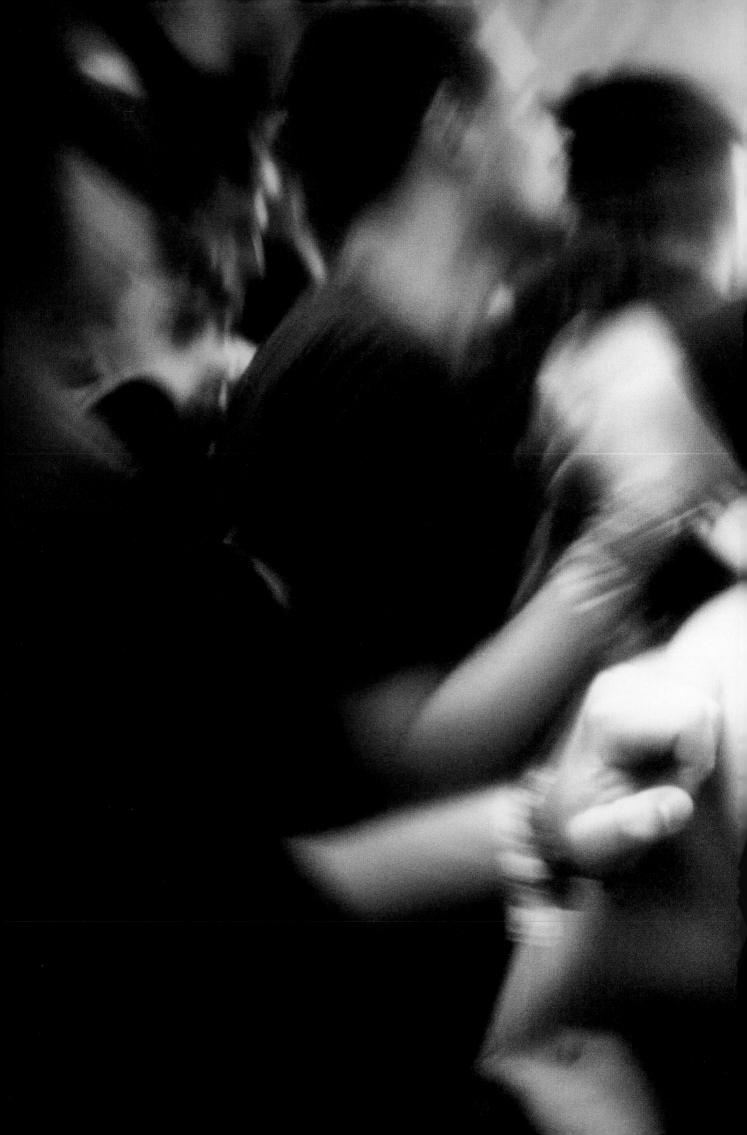

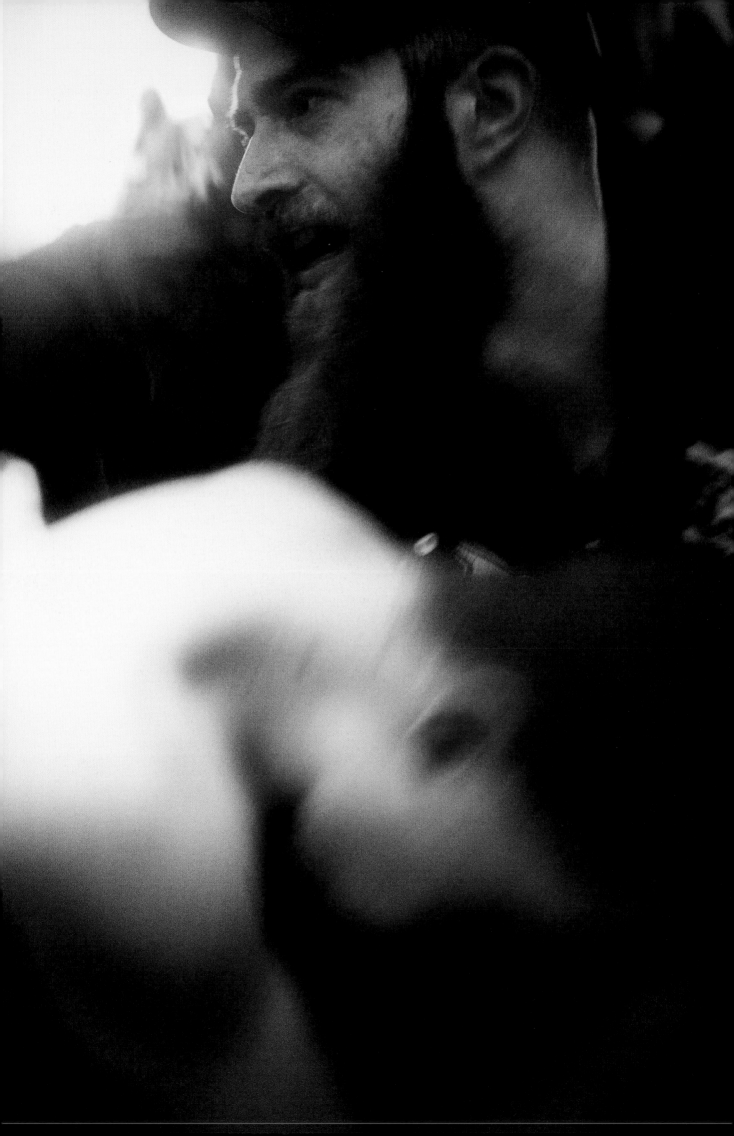

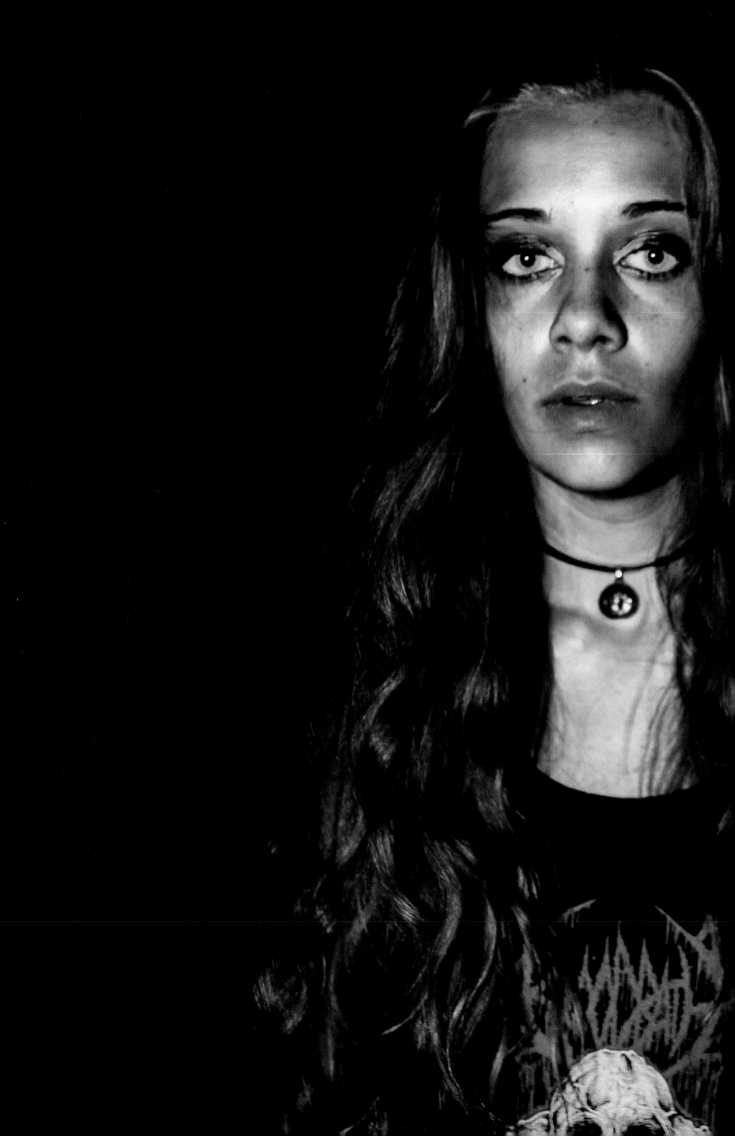

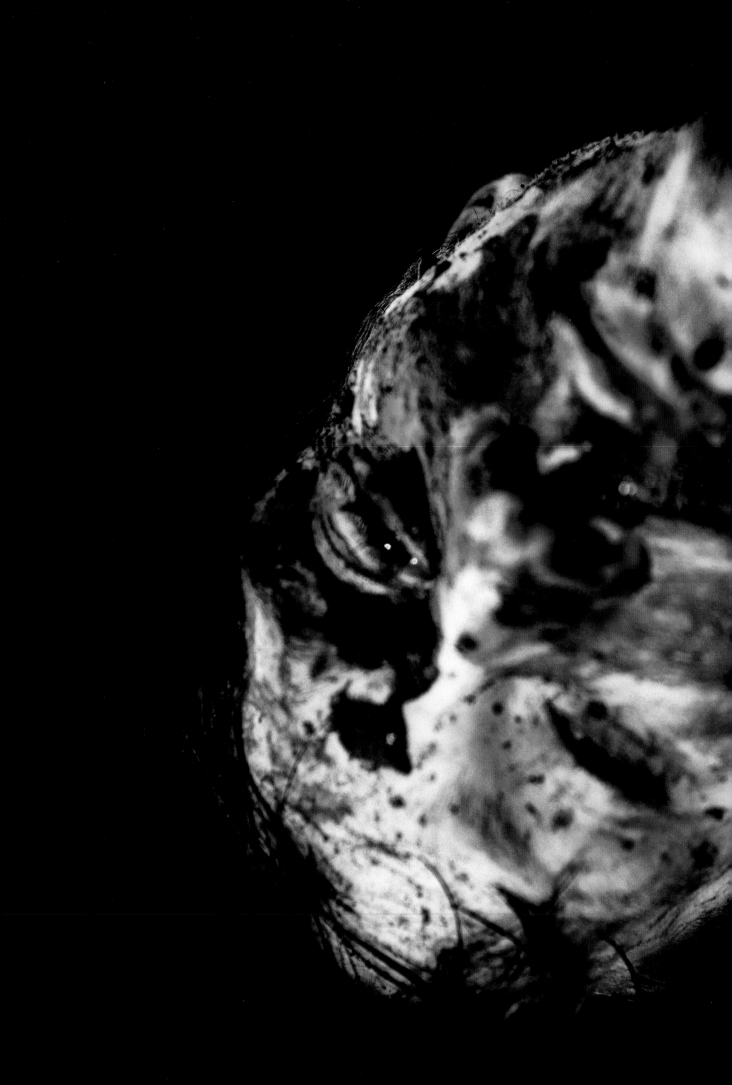

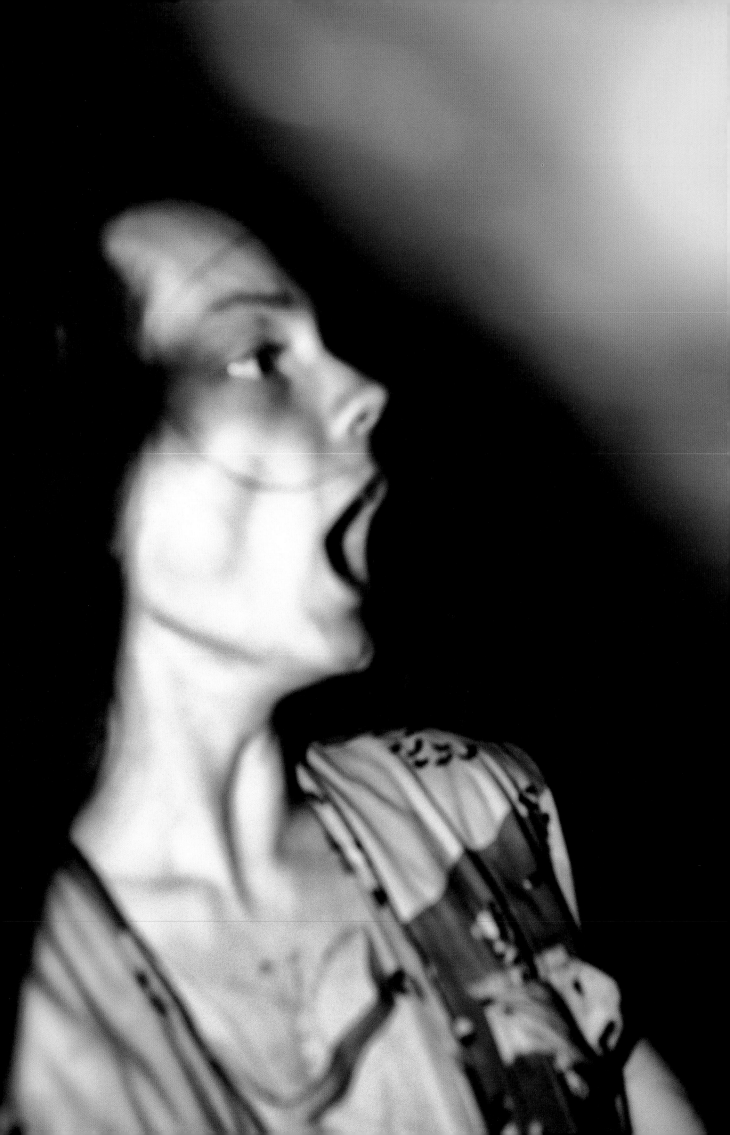

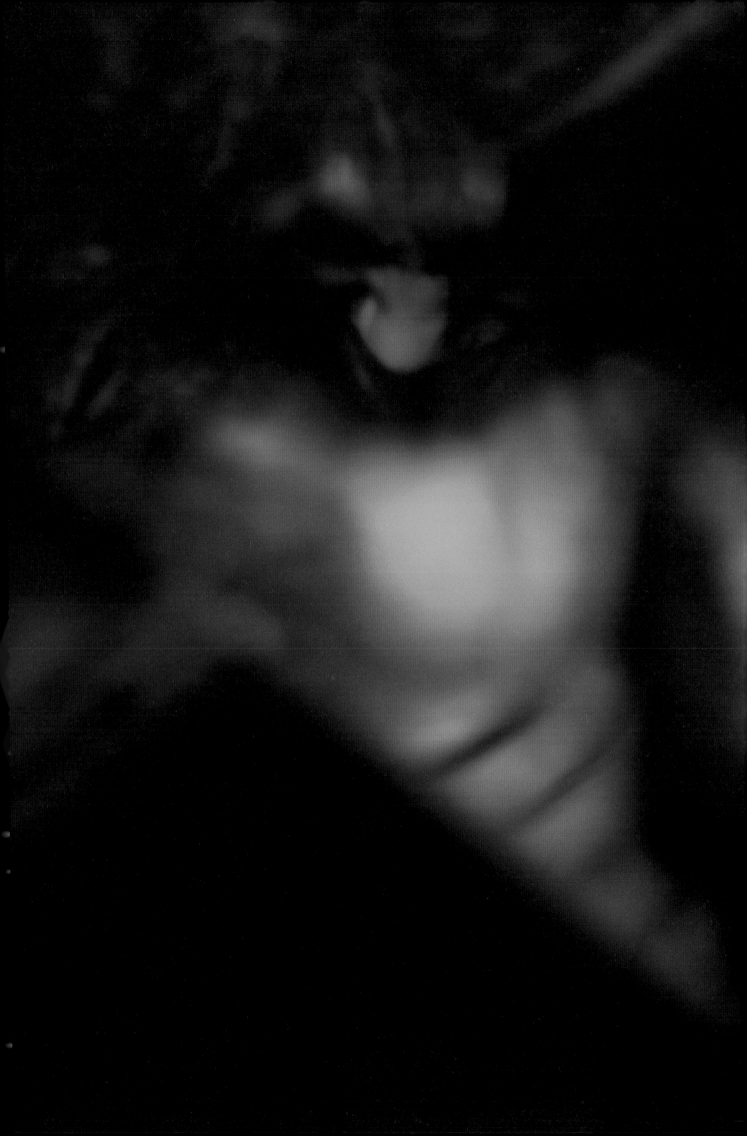

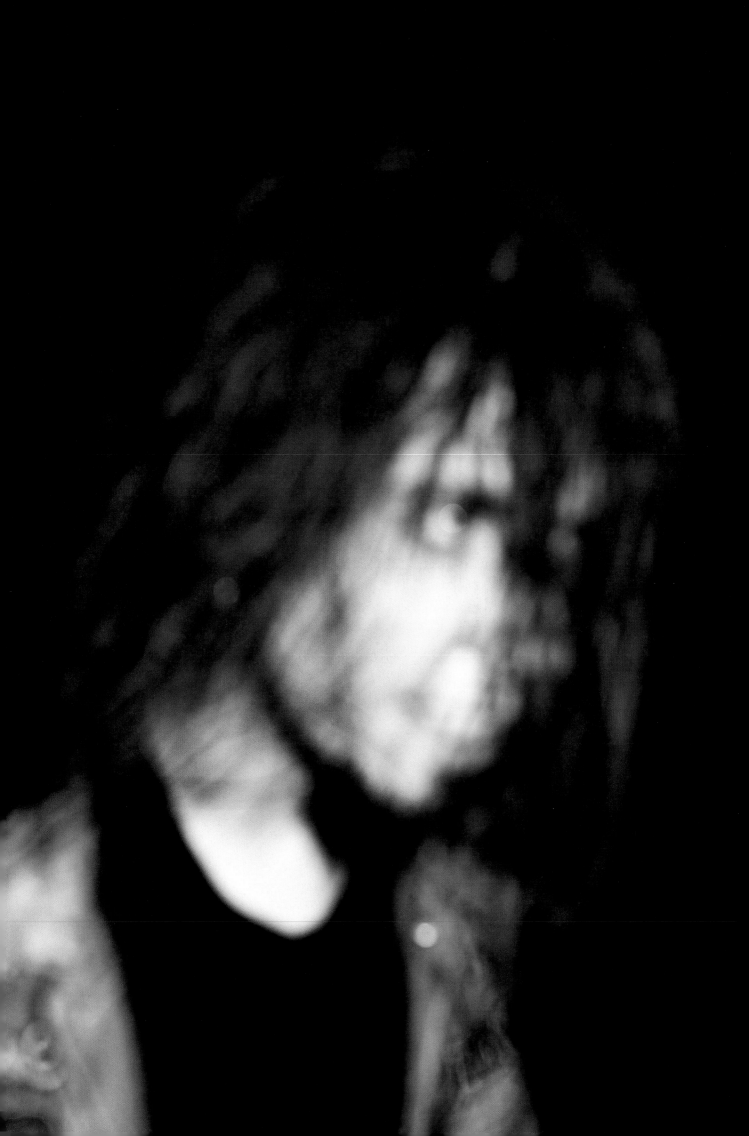

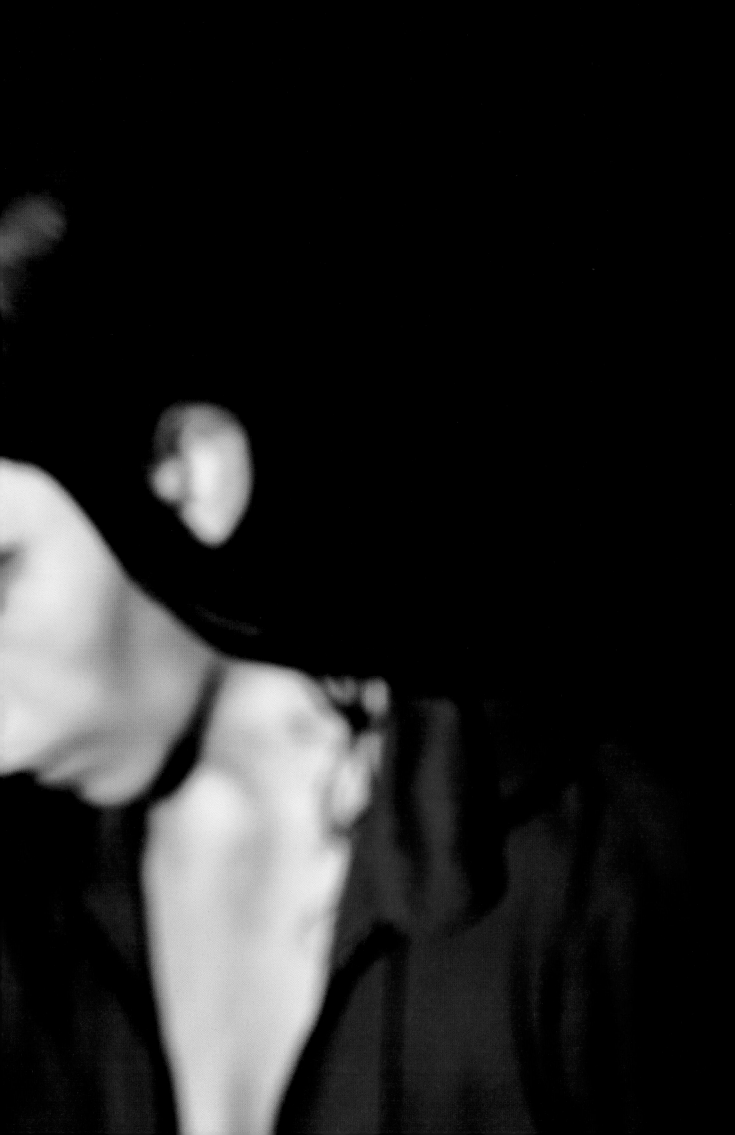

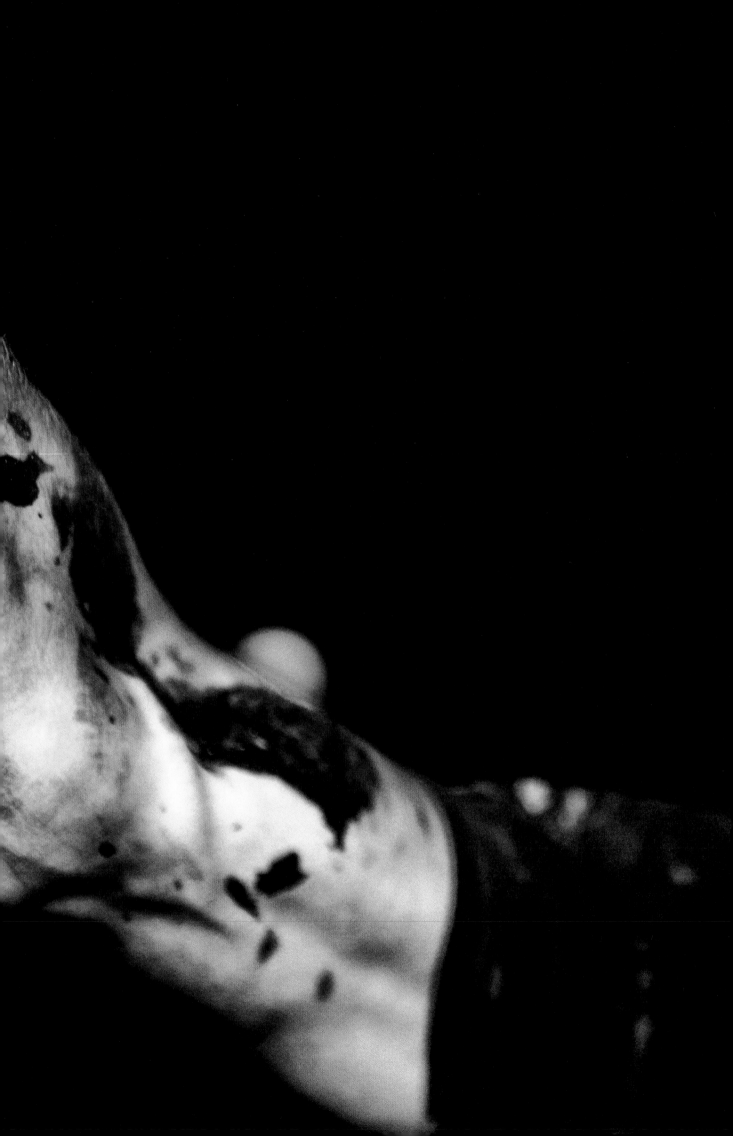

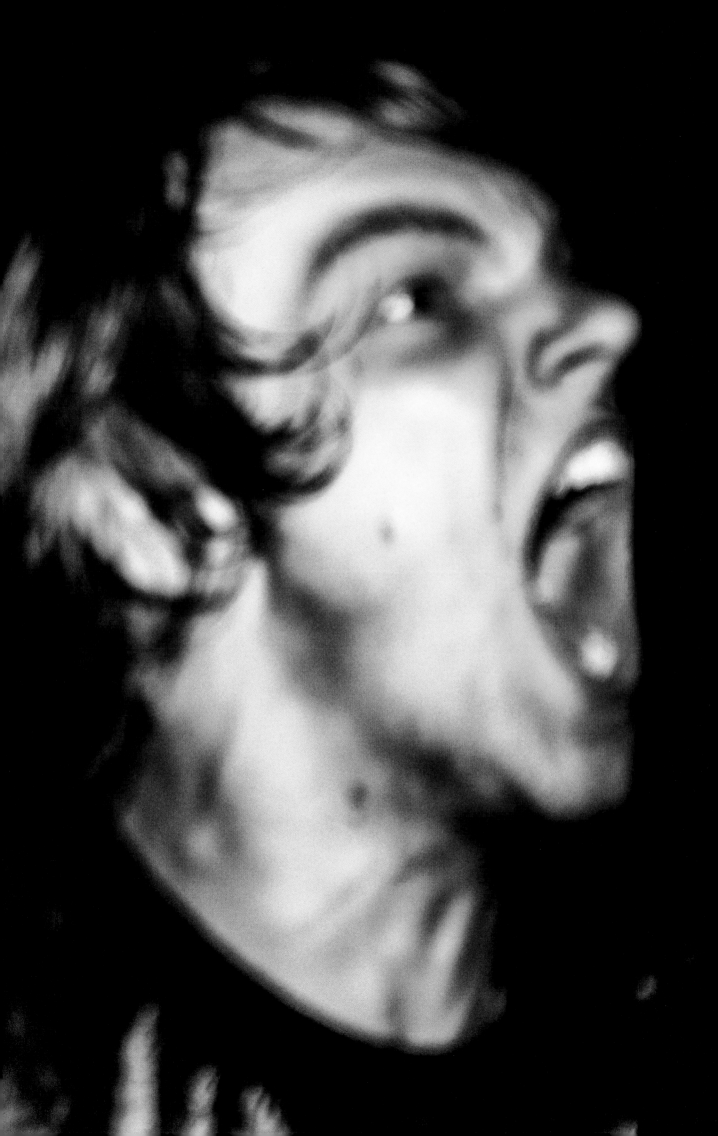

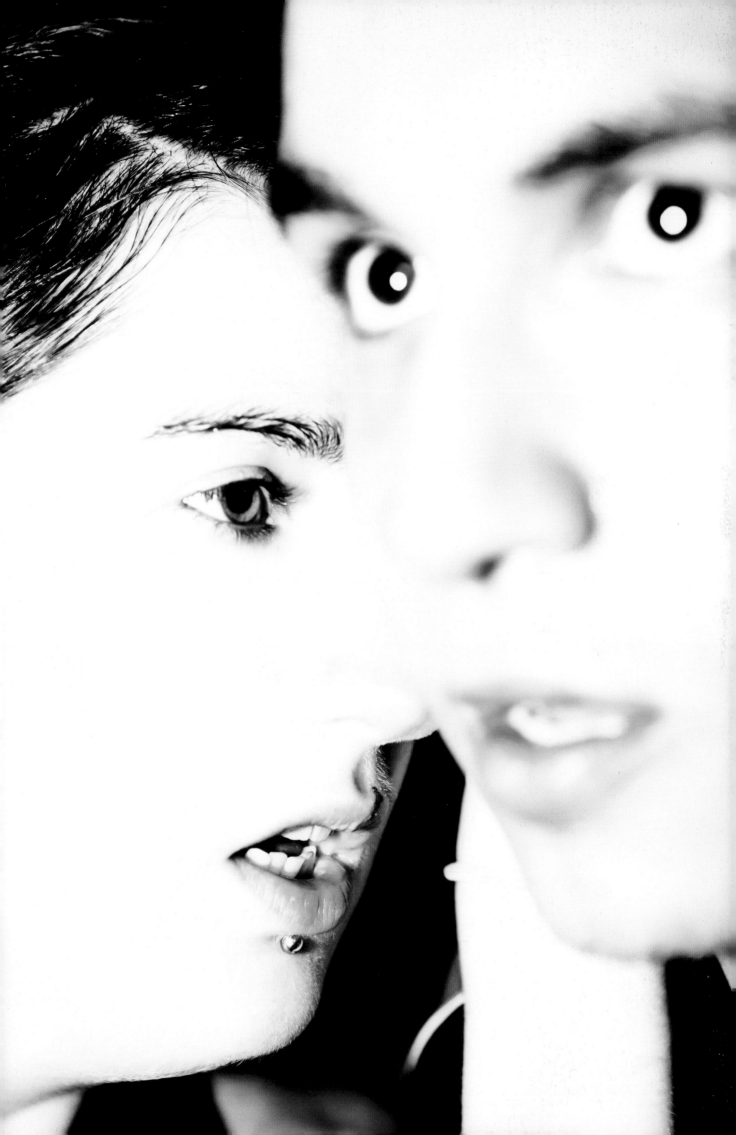

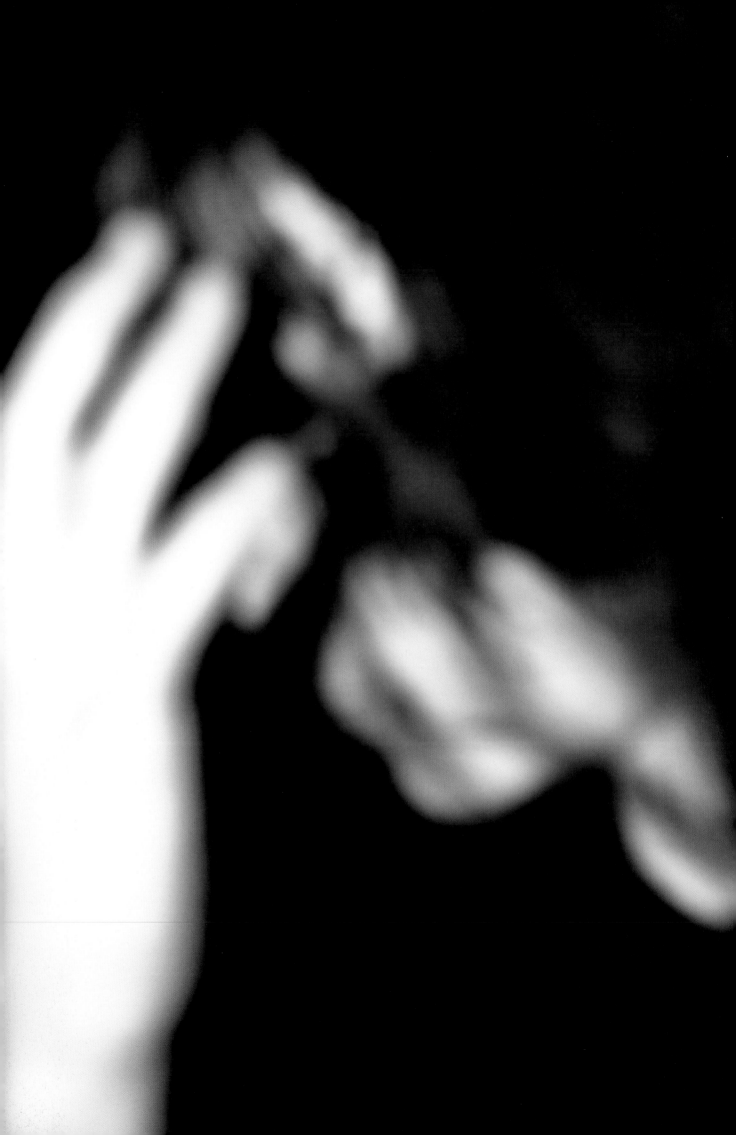

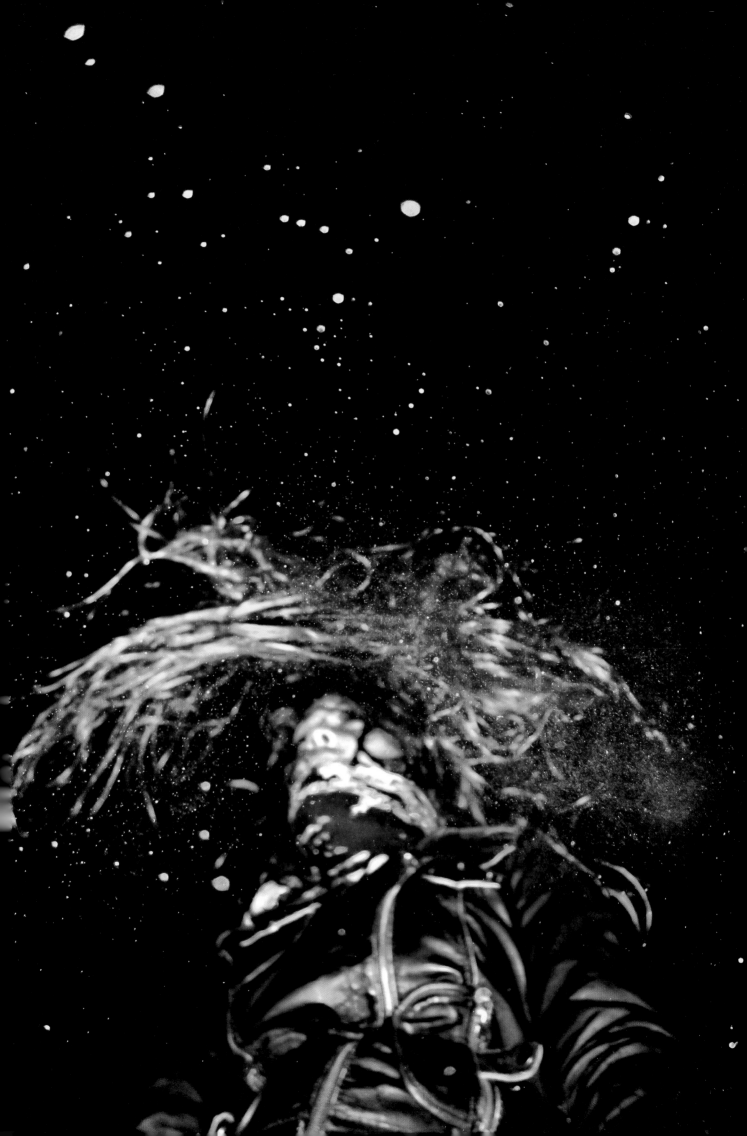

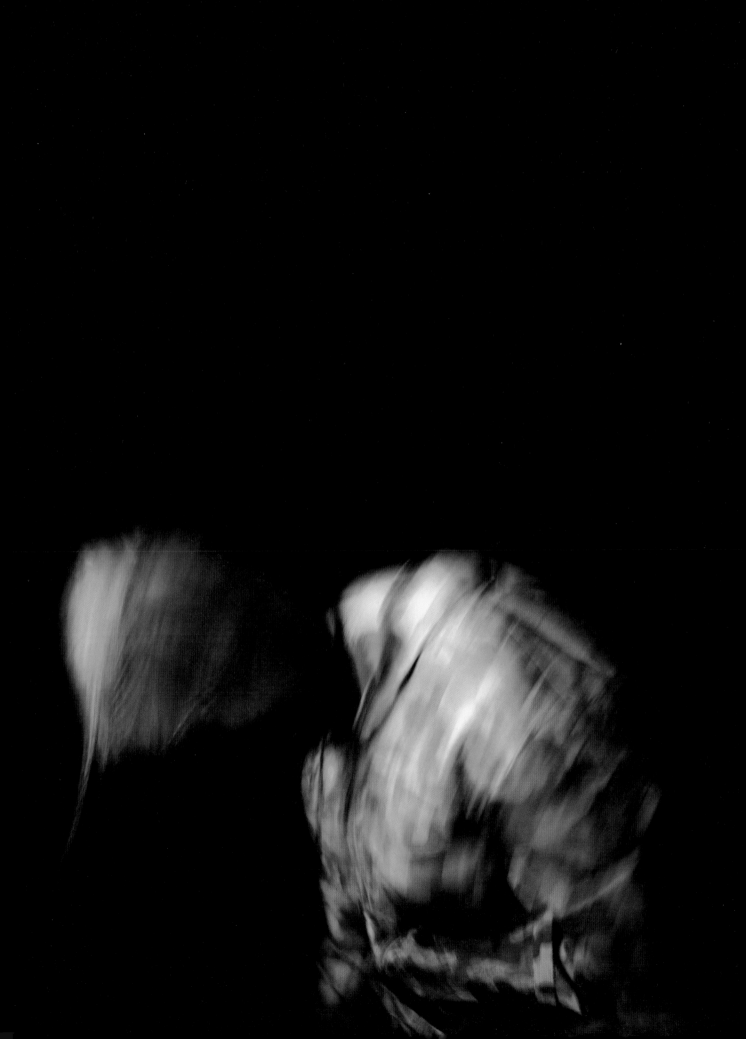

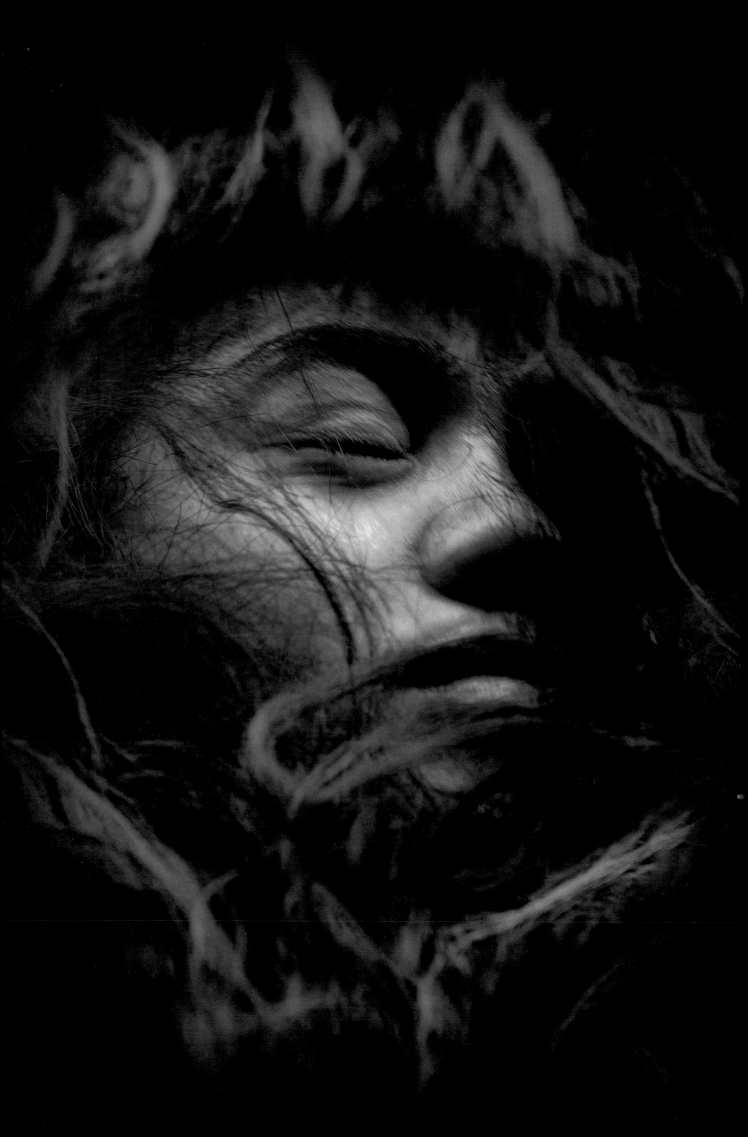

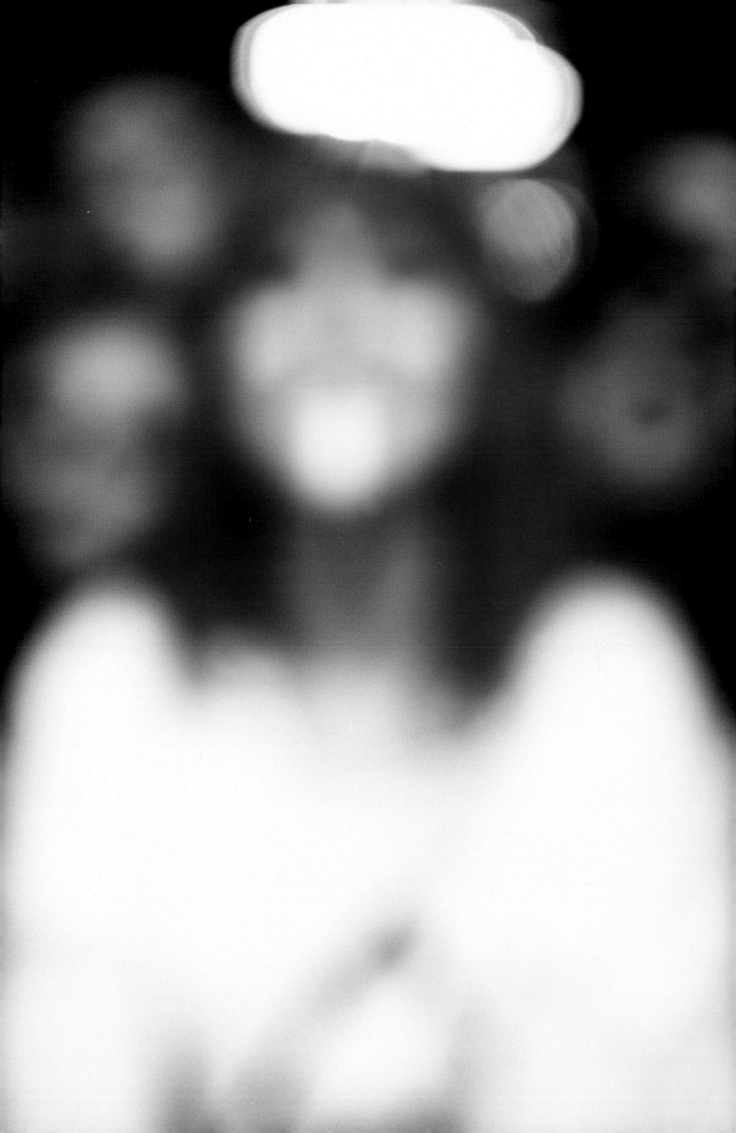

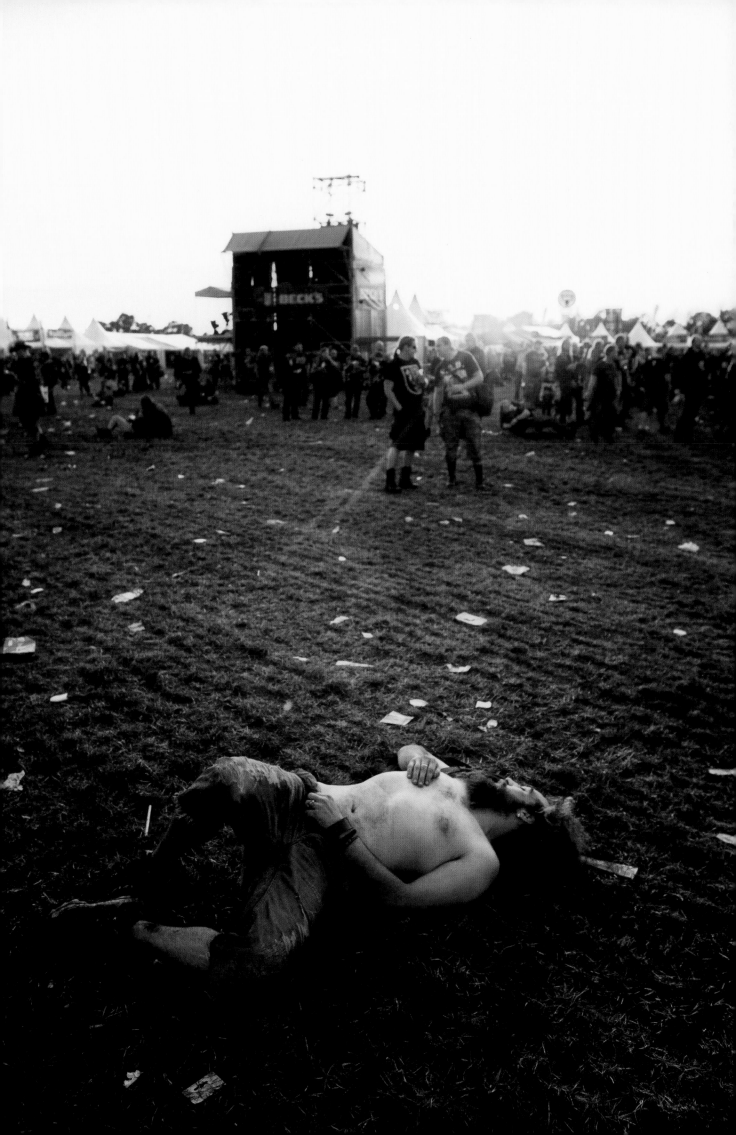

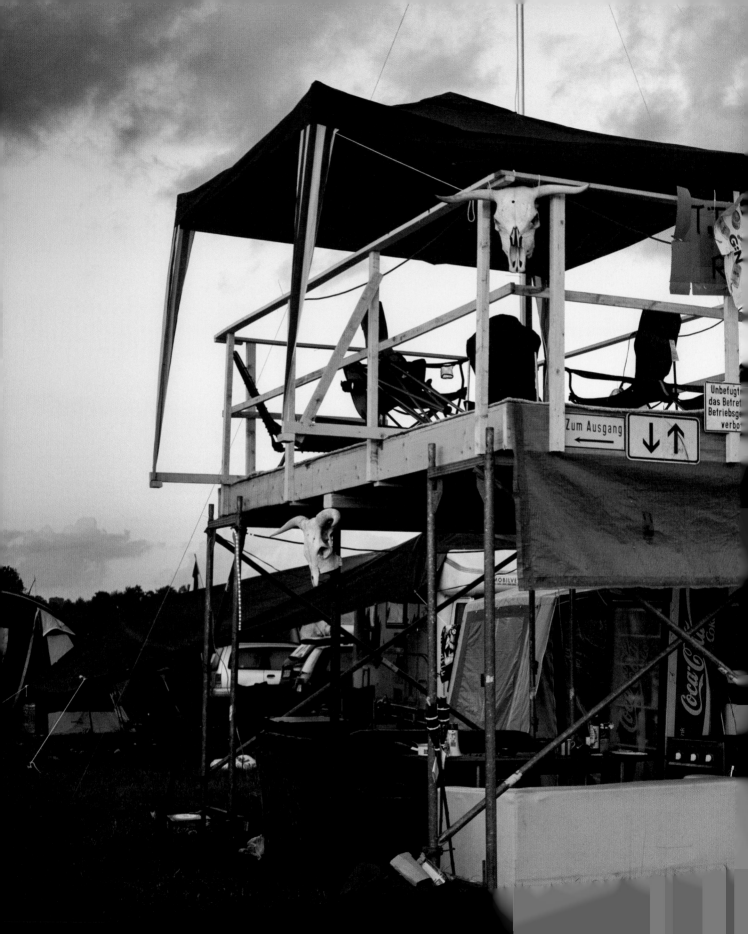

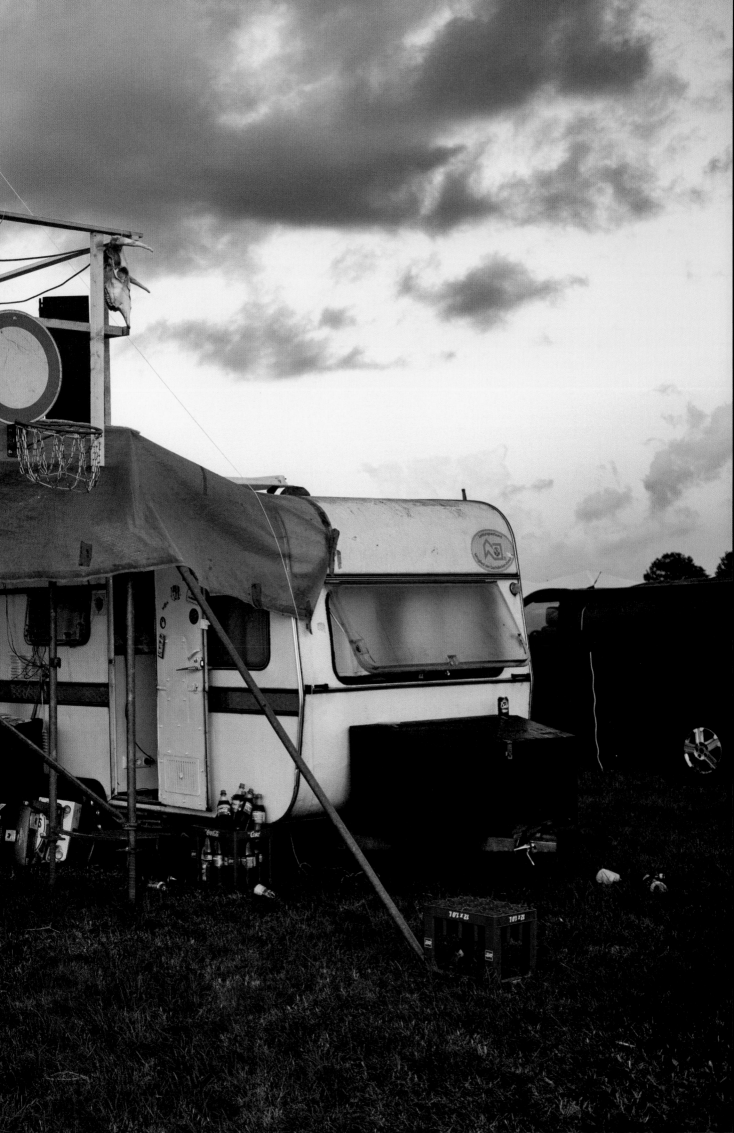

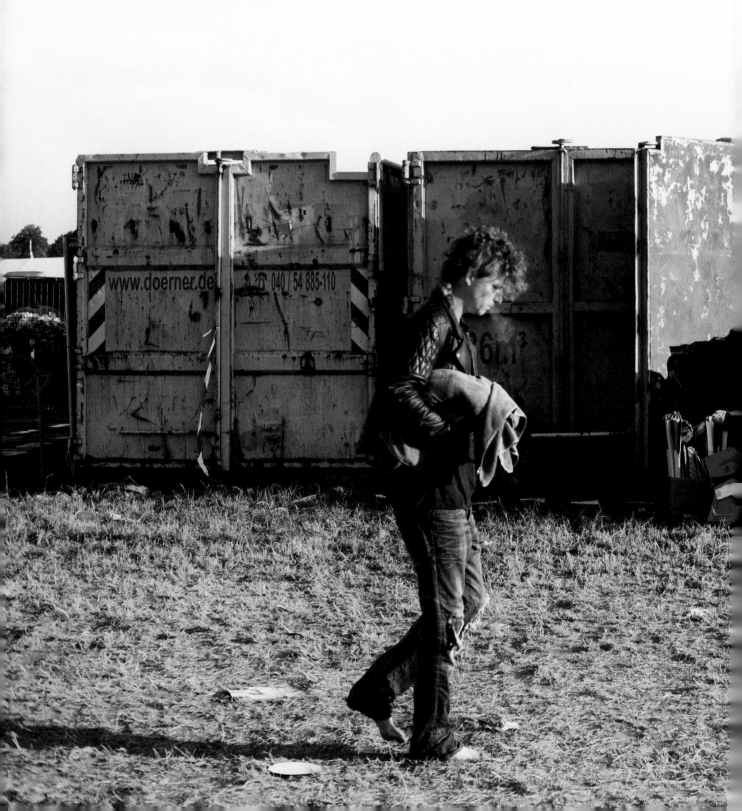

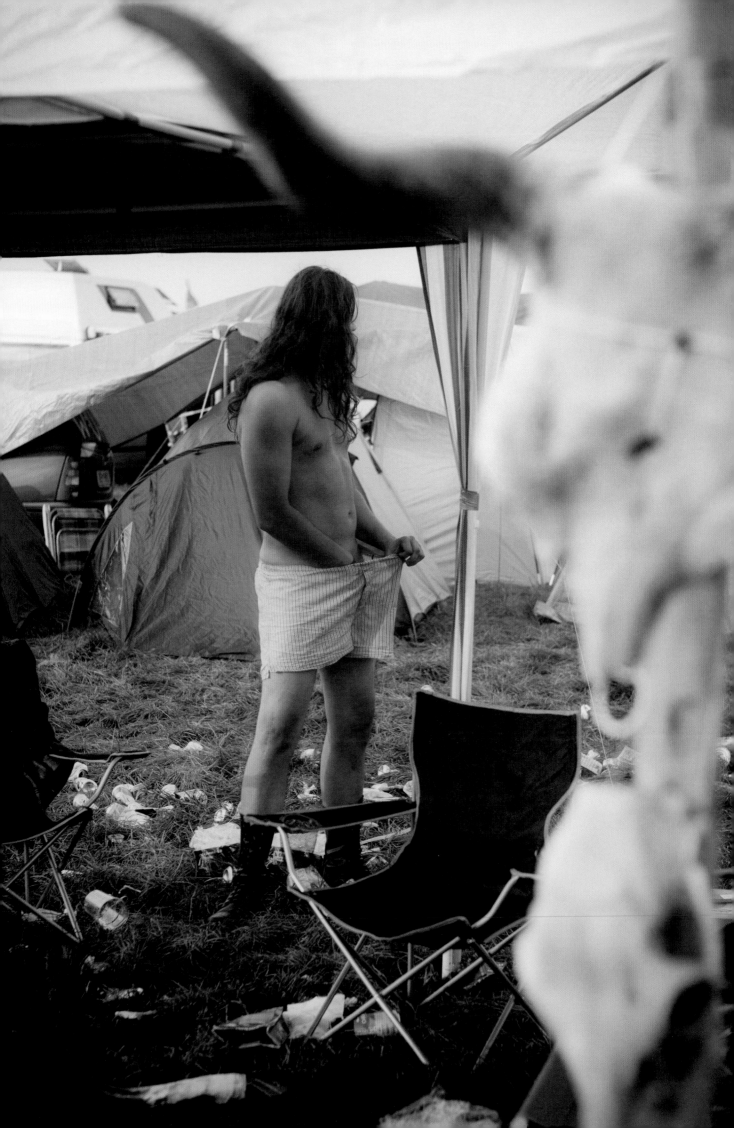

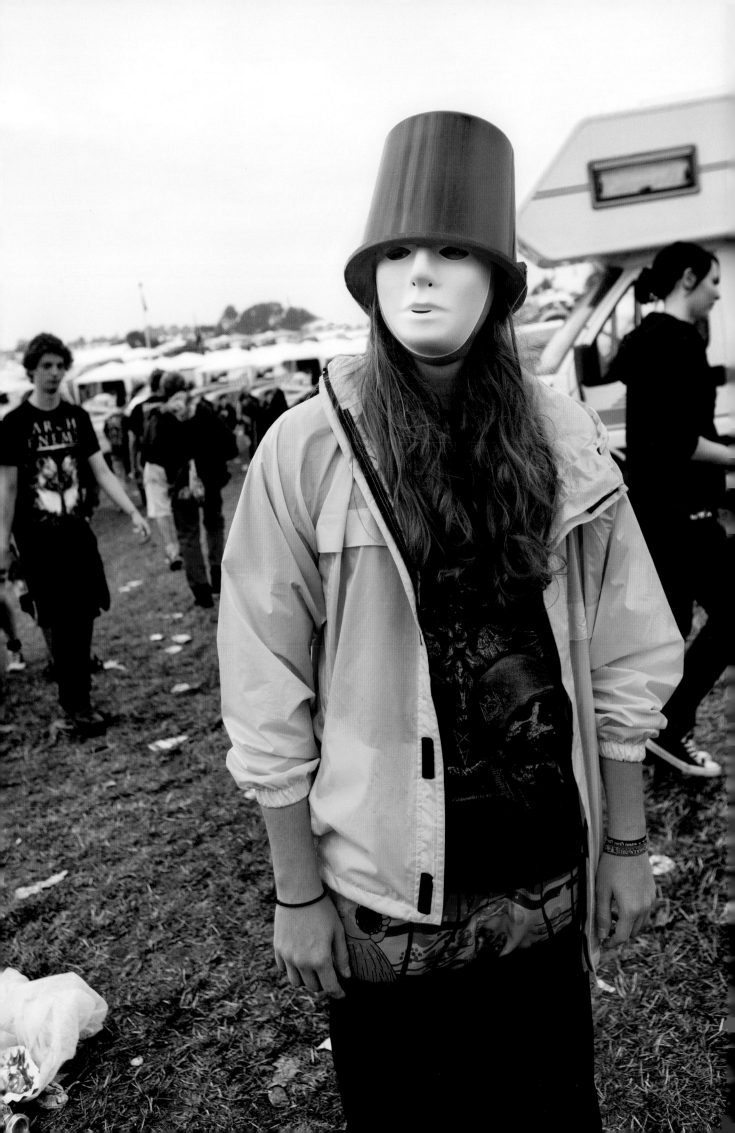

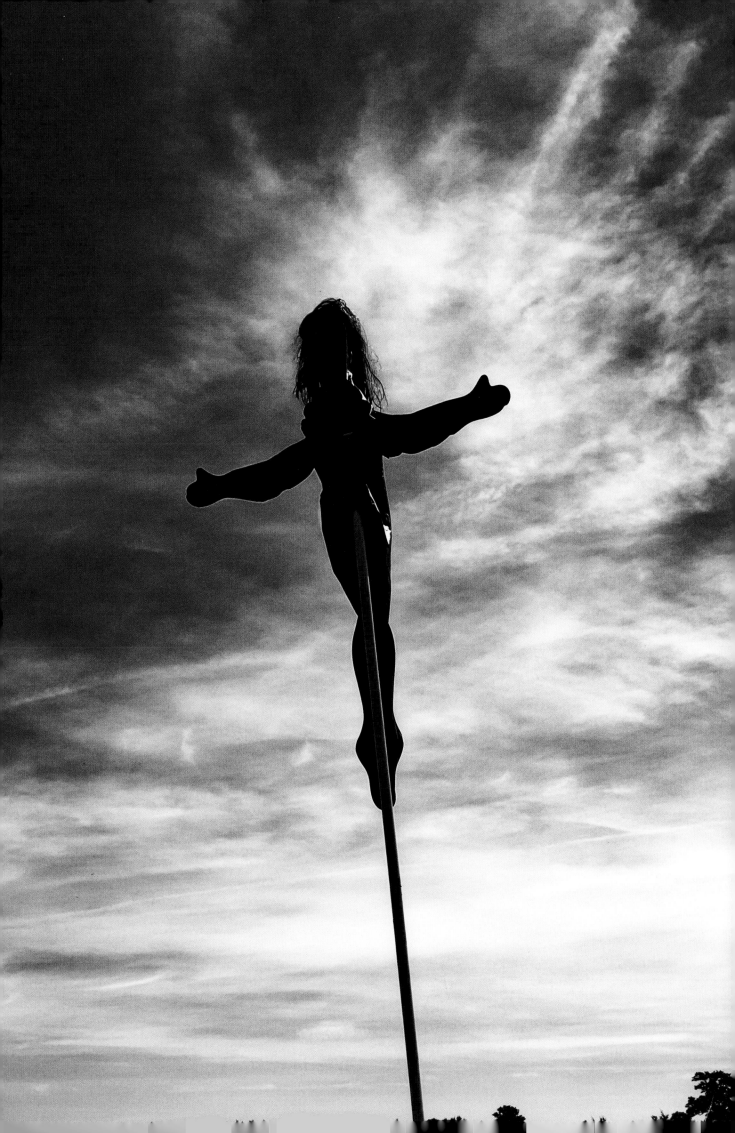

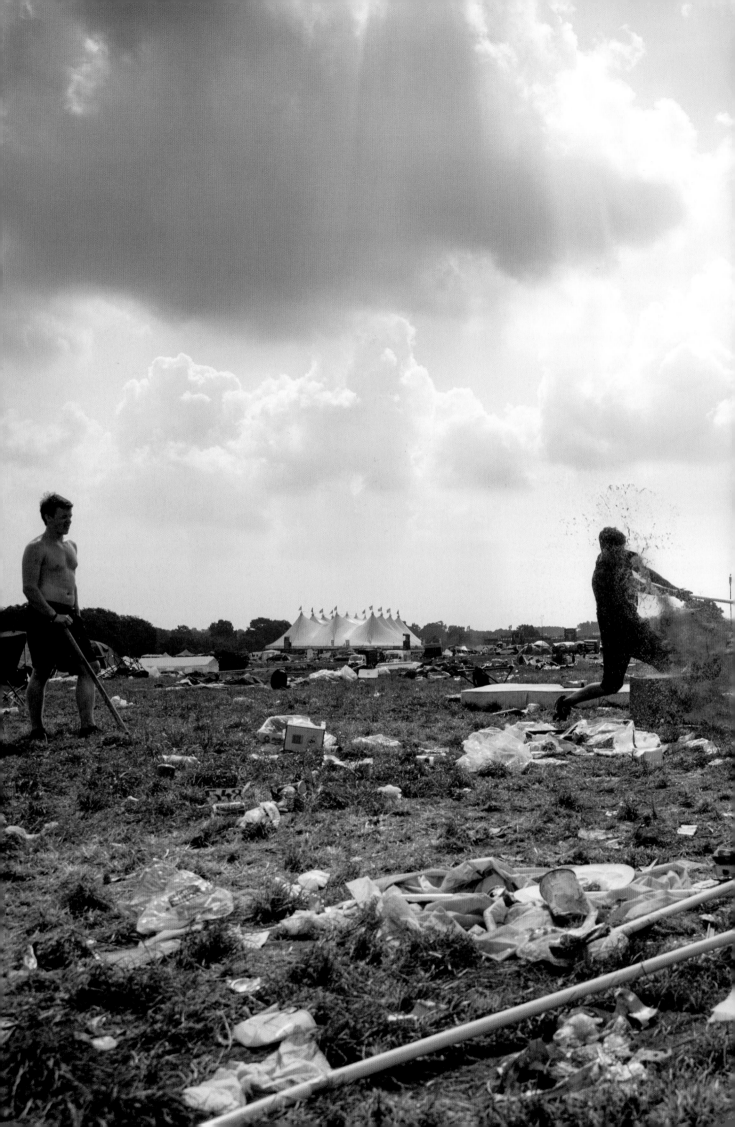

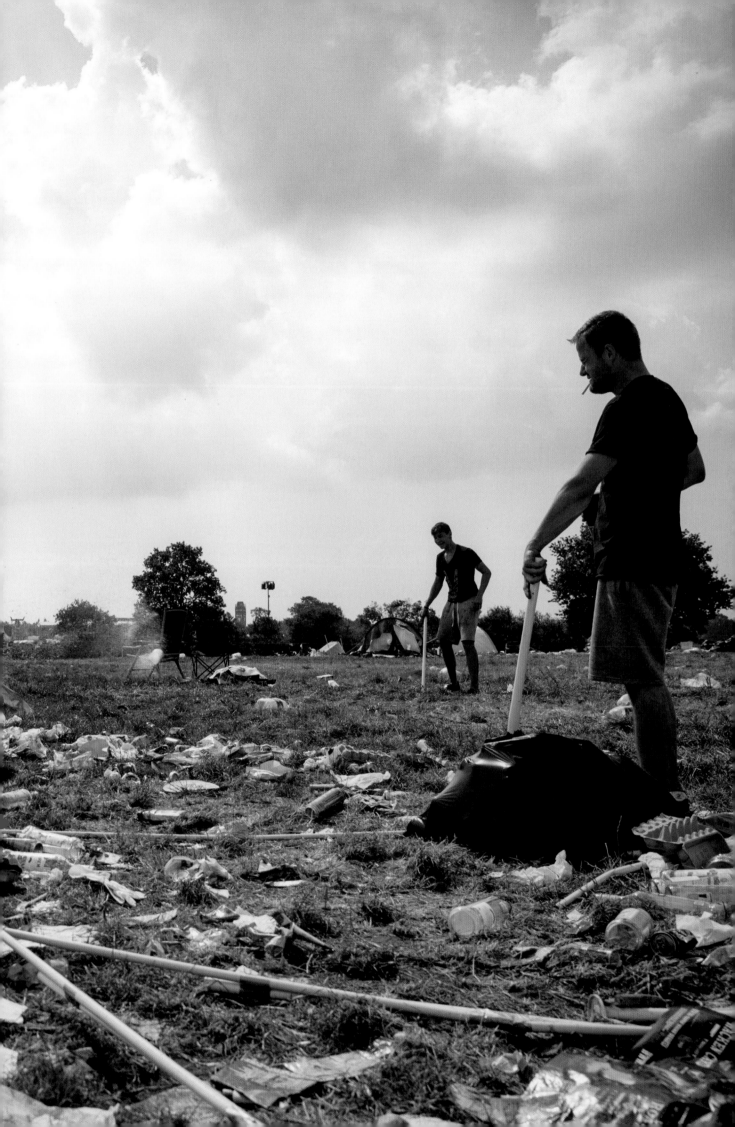

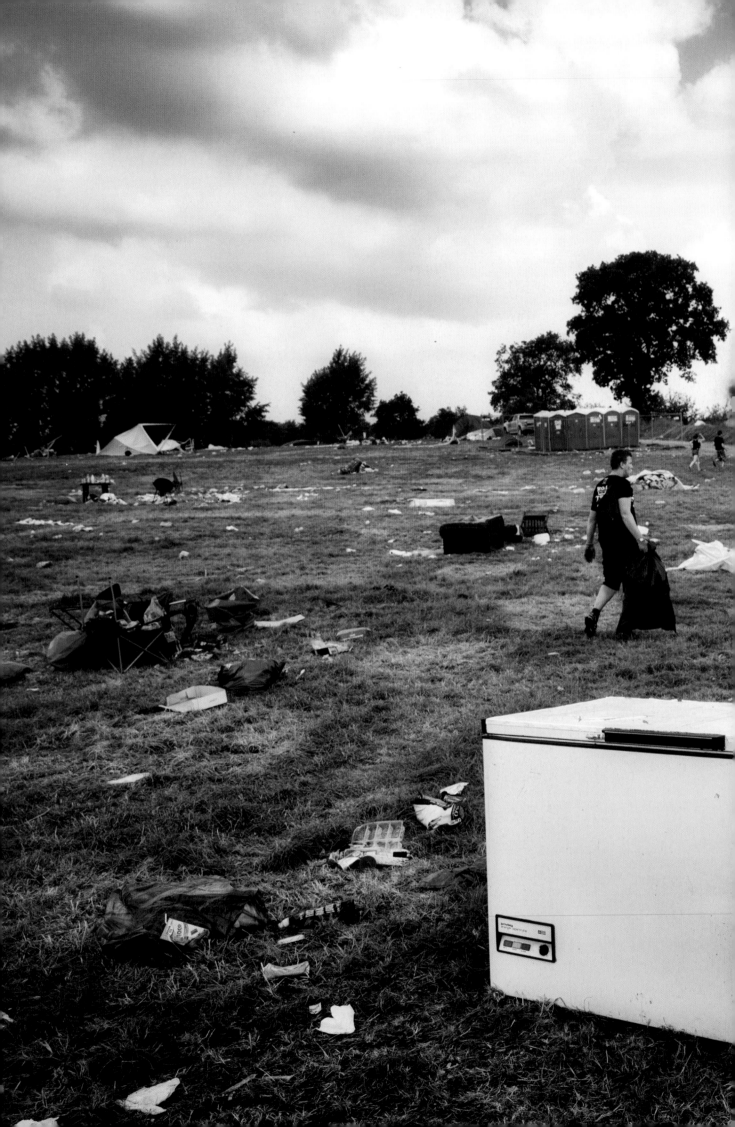

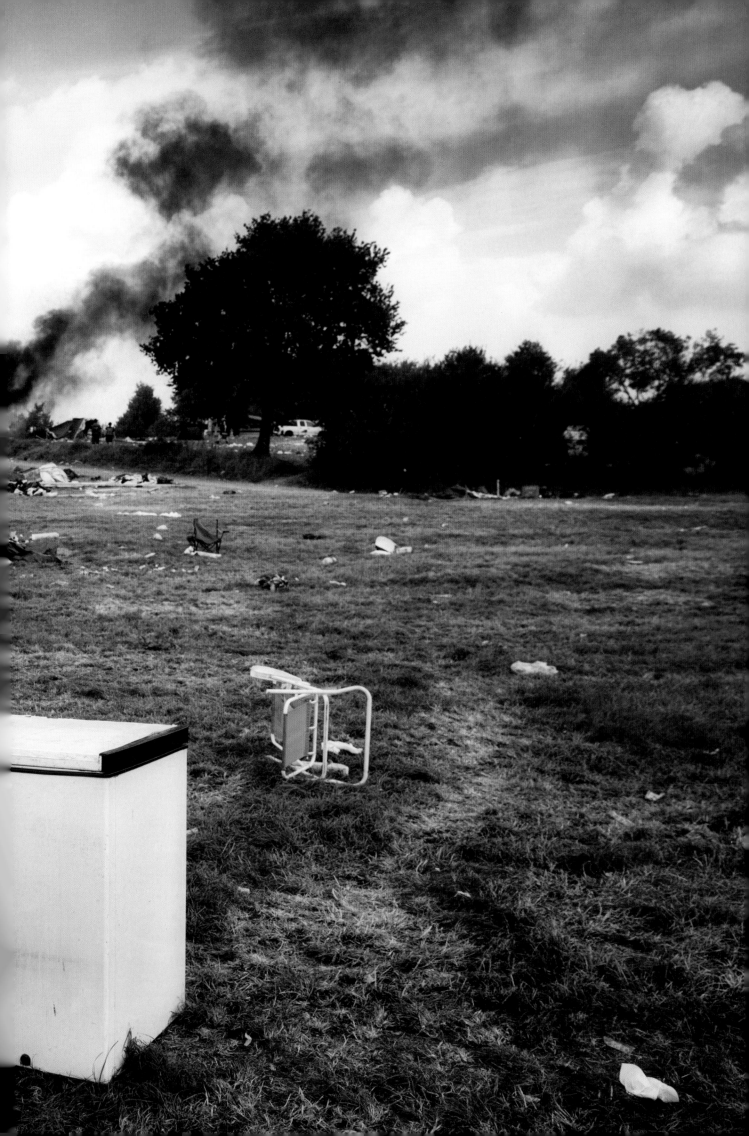

WE WANT MORE

THANKS TO ALL THE METALHEADZ – IN METAL WE TRUST.

I have taken these Photos with all care, conciousness and respect to the people that are seen here and the Festival. I made all efforts to find all of you again. But you know how it is in Wacken. Please contact me if you find yourself in this book.

www.jensnolte.com

THANKS
I want to thank my friends and family for believing in me. Vera and Leni – my little family. Eberhard Nolte, Kelly & Fam. Kellermanns, Kerstin Bunke, Jürgen Dahlhoff, Andreas Kühlken, Eija Mäkivuoti, Jan Höffken, Chriss Schneider, Tobias Lichtenberg, Steffen Kress, Christopher Becker, Jörg Maas, Elmar Sommer, Thomas von der Heiden, Franz Koenig, Andrea Briegmann, Thomas Ruff, Boris Kaiser & RockHard Magazine, WOA Management, Sigrid Noll-Einhaus, Peter Scharf, Juan Sebastian Villa Ortiz, Birte Kreft & Kerber Verlag & all the awesome people who I might have forgotten to mention.

&

To all the people who helped me to make this book and supported this and future projects by buying it.

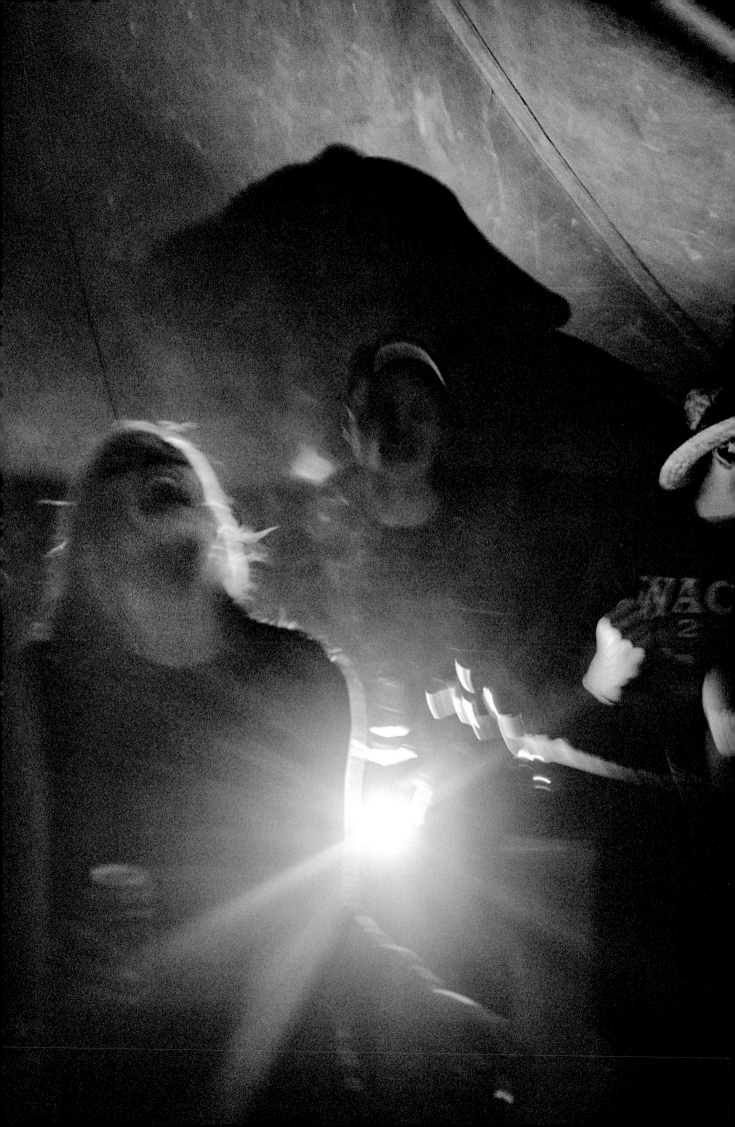

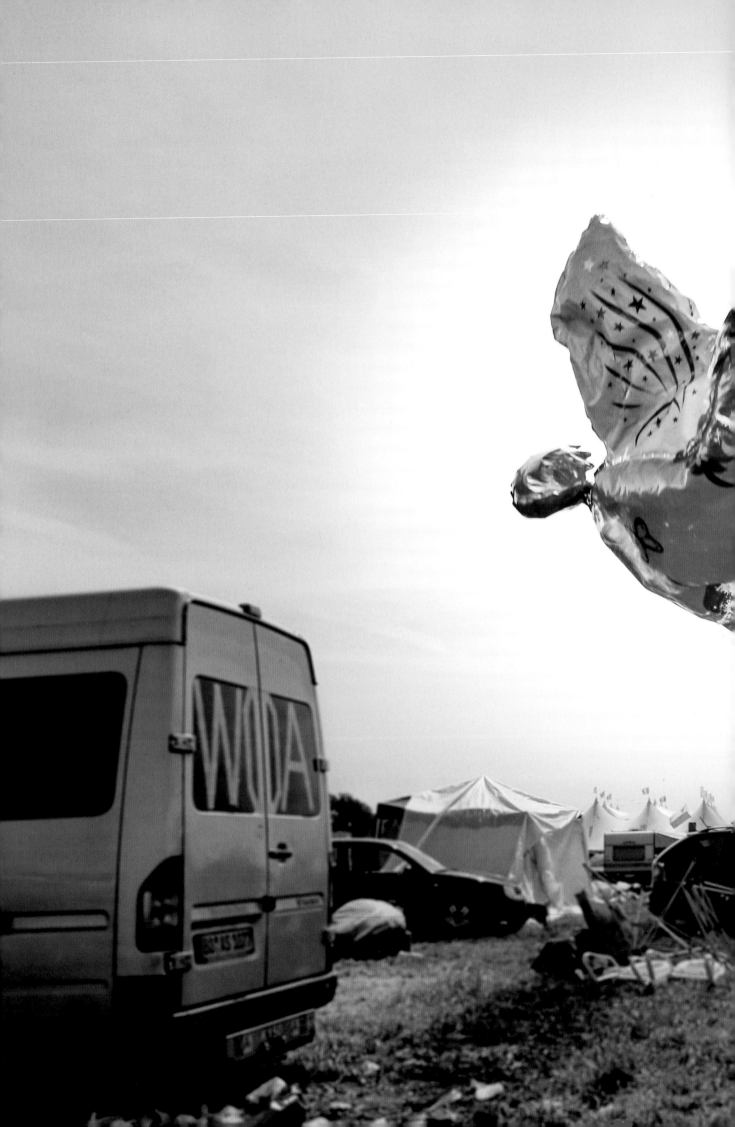

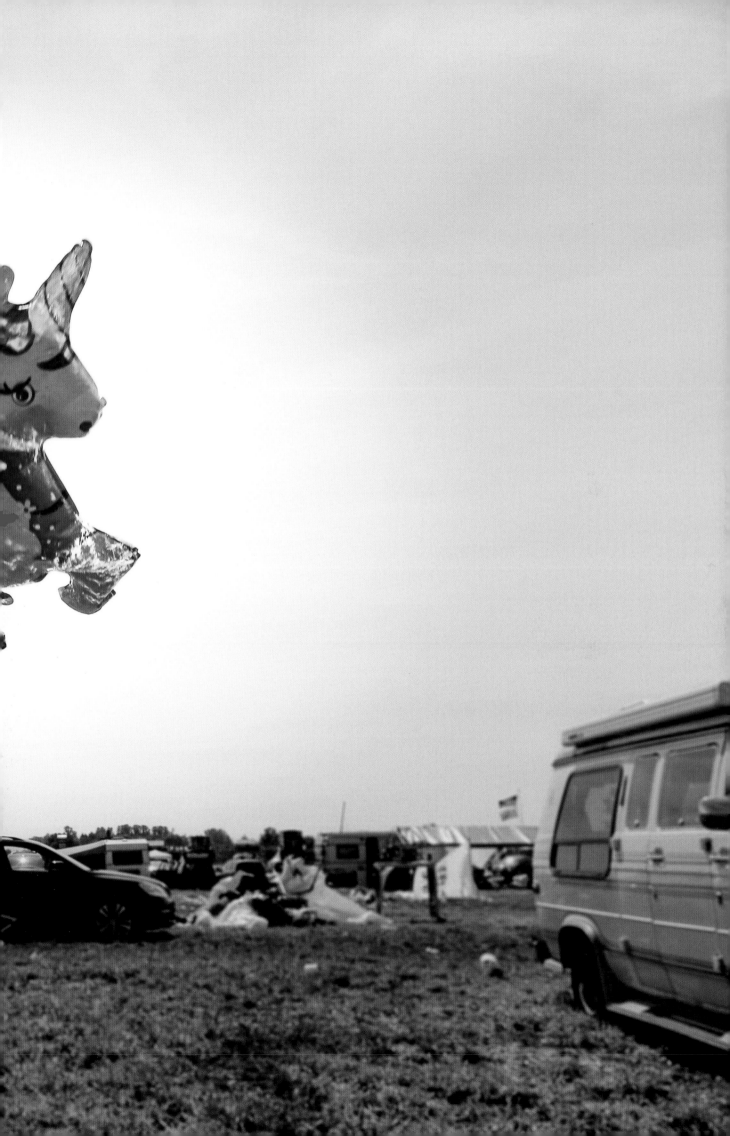

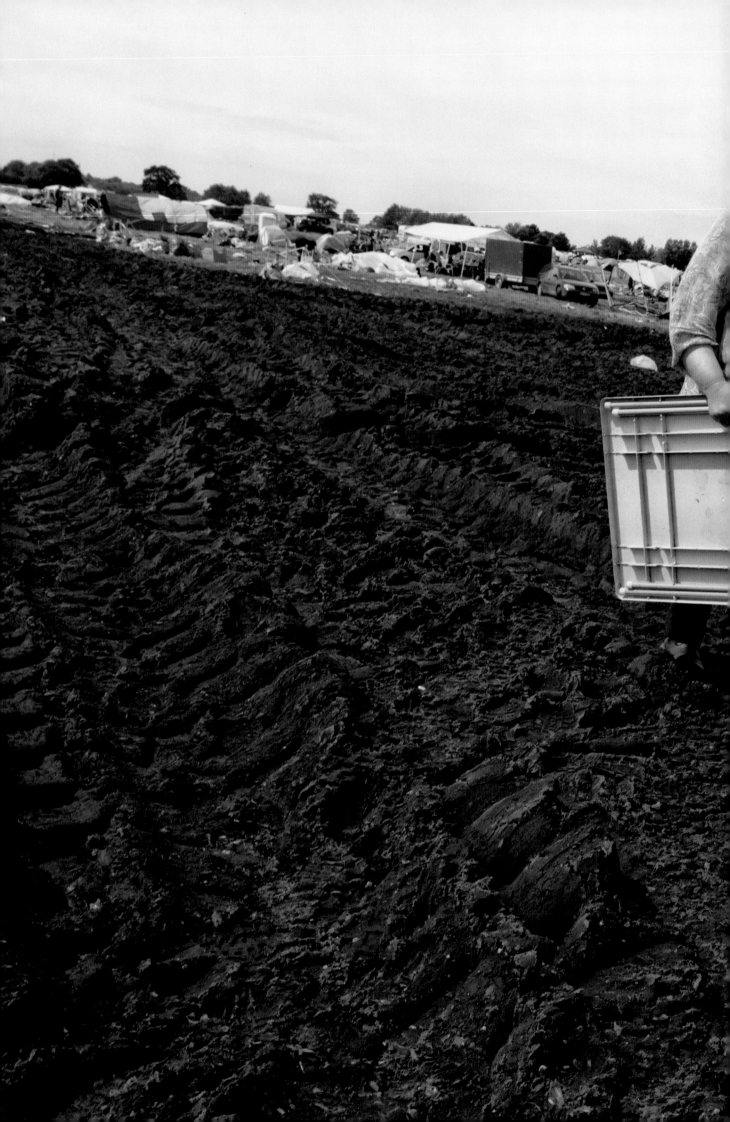

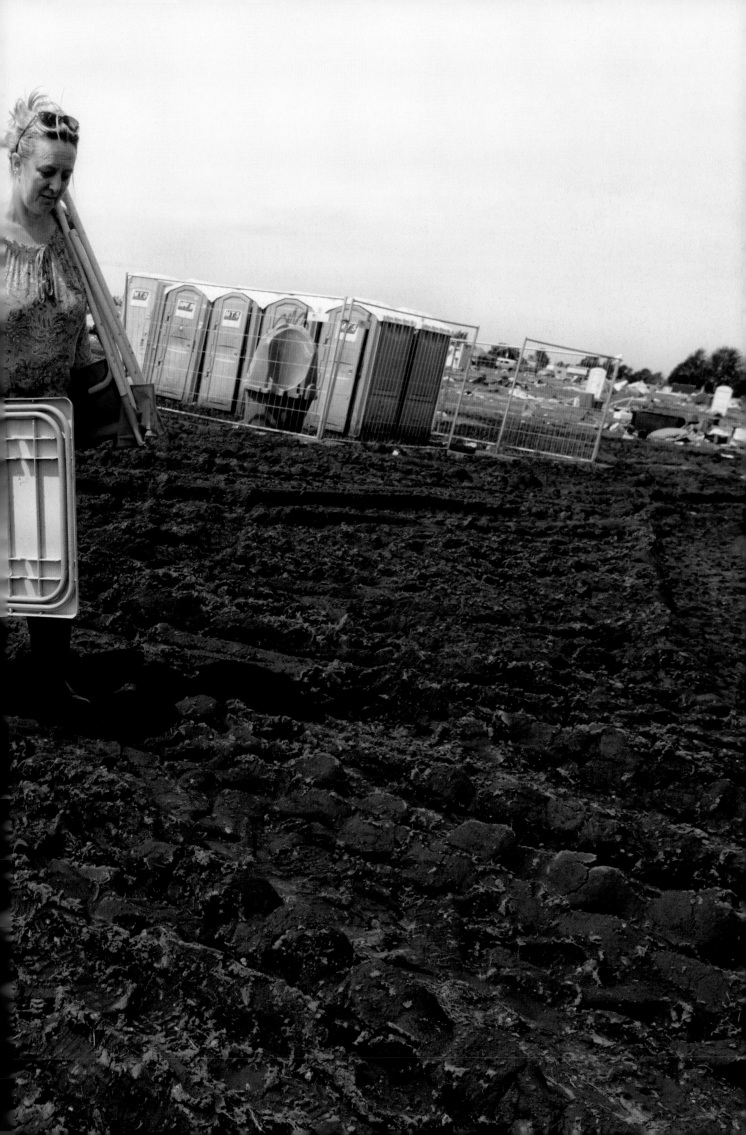

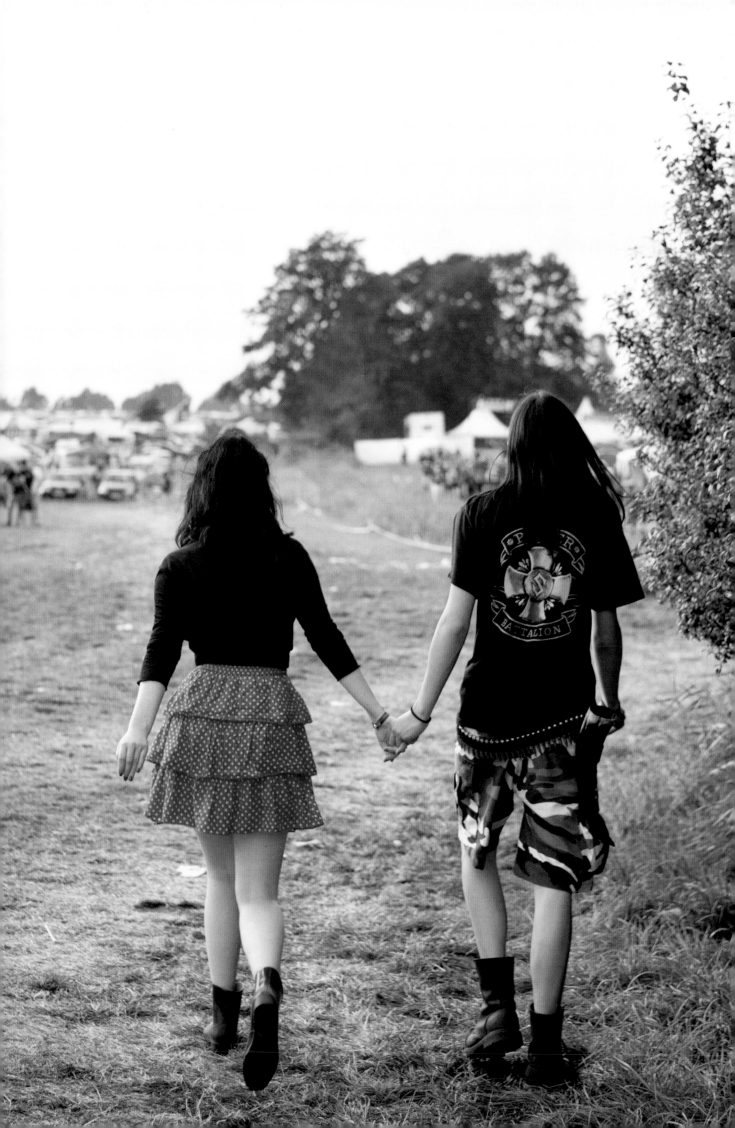

RUNNING ORDER

Overkill
2012

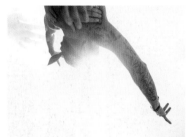
Kvelertak
2015

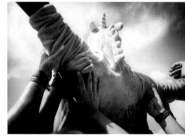
Sunrise Orchestra
2014

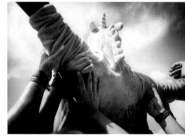
Anthrax
2013

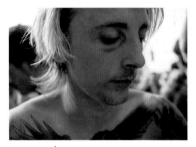
Bring Me the Horizon
2014

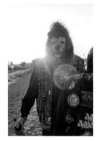
Sodom
2011

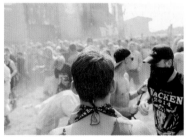
Bring Me the Horizon
2014

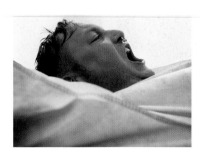
Heaven Shall Burn
2014

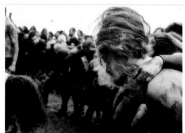
Opeth
2014

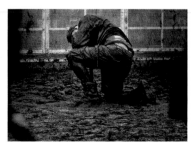
Dream Theater
2015

Sabaton
2013

Testament
2012

Morbid Angle
2011

Suicidal Tendencies
2011

Six Feet Under
2012

In Flames
2012

Doro
2013

Bloodbath
2015

Kreator
2011

Kreator
2014

Motörhead
2011

Judas Priest
2015

Machinehead
2012

Avantasia
2014

Grave Digger
2013

Children of Bodom
2011

Amon Amarth
2012

W.A.S.P
2014

Slayer
2014

Alice Cooper
2013

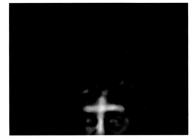

Cradle of Filth
2012

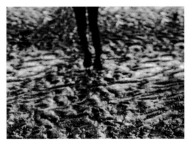

Scorpions
2012

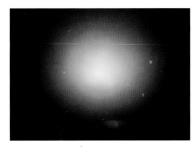

Supernova Wacken
2015

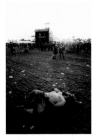

Rob Zombie
2015

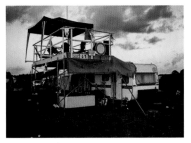

Sunrise Orchestra
2012

Megadeath
2014

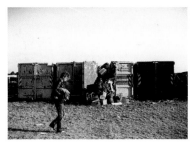

Endstille
2014

Steel Panther
2014

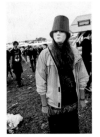

Sepultura
2011

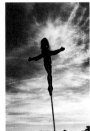

Amorphis
2015

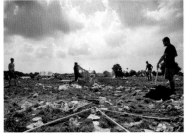

Black Label Society
2015

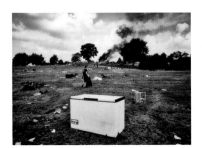

W.O.A. Firefighters
2014

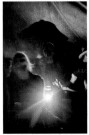

Aftershow
2012

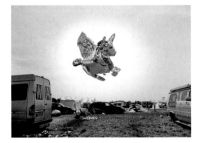

Pagan Blues
2015

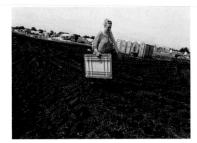

At the Gates
2015

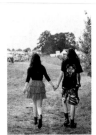

The BossHoss
2012